Underwater Worlds

COLORING MAGICAL DEPTHS

Renata Krawczyk

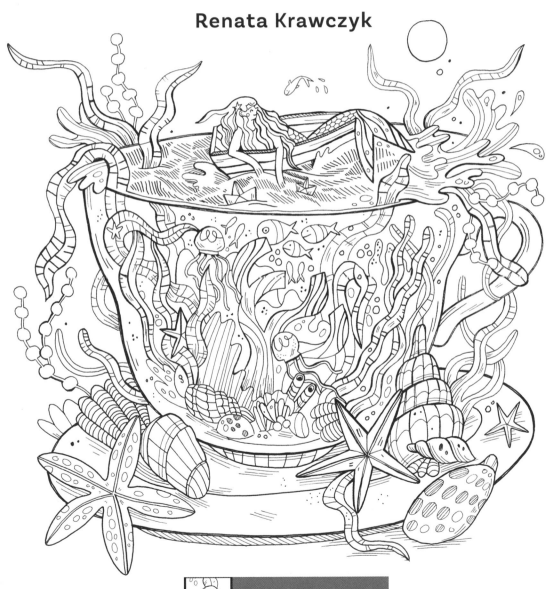

 Get Creative 6

NEW YORK

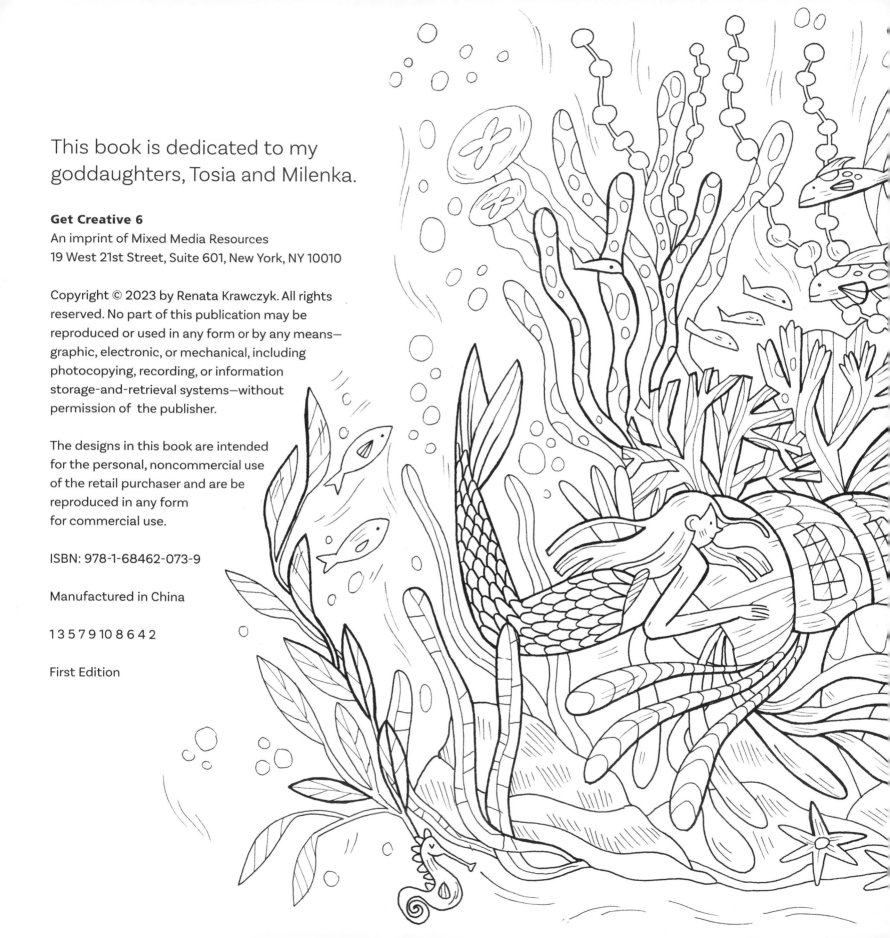

This book is dedicated to my goddaughters, Tosia and Milenka.

Get Creative 6
An imprint of Mixed Media Resources
19 West 21st Street, Suite 601, New York, NY 10010

ISBN: 978-1-68462-073-9

Manufactured in China

1 3 5 7 9 10 8 6 4 2

First Edition

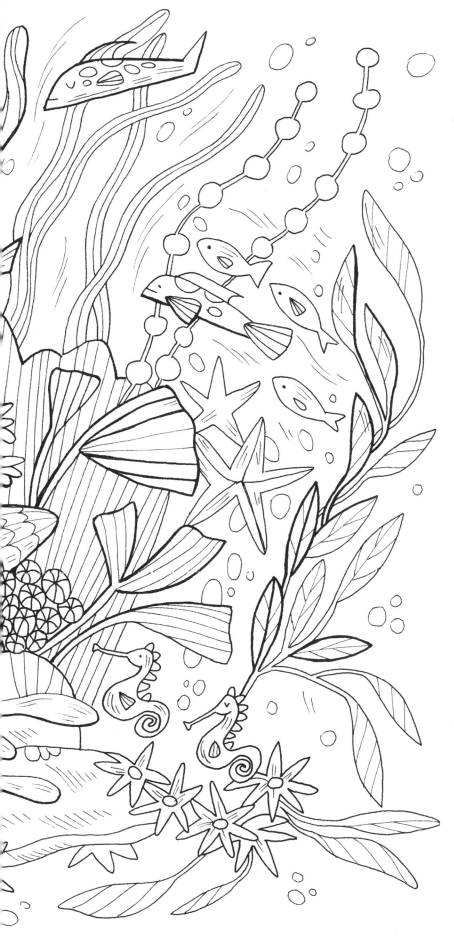

Introduction

We meet once again, and it is an enormous pleasure for me to take you on a trip to another of my illustrated wonderlands.

This time, we plunge deep into my imaginary underwater worlds, each lush with coral and seaweed, teeming with sea life both large and small, and sprinkled with seashells. Reality and fairy tale mingle in these scenes for an excursion like no other.

Look carefully and you will find paper boats, shelters made of seashells, secret letters in bottles hidden somewhere on the sea bed, funny octopuses, celebrating dolphins, and many other surprises. Mermaids, together with cheerful crabs and schools of seahorses, swim among beautiful underwater plants and coral reefs, waiting for you to join in the fun. Such amazing, lively worlds demand color!

All of the illustrations in this book were created with pen, ink, paper, and my own hands. In a time with so many means of electronic communication and digital illustration, returning to the creative process of more traditional techniques gives me tremendous pleasure. There is no ctrl+z to undo something, therefore, sometimes even I cannot predict the final outcomes. I adore creating tiny magical worlds made of the smallest details, and my wish is that your journey of coloring these images is just as thrilling and unpredictable as my experience of drawing them.

I hope this voyage will captivate you!

—Renata

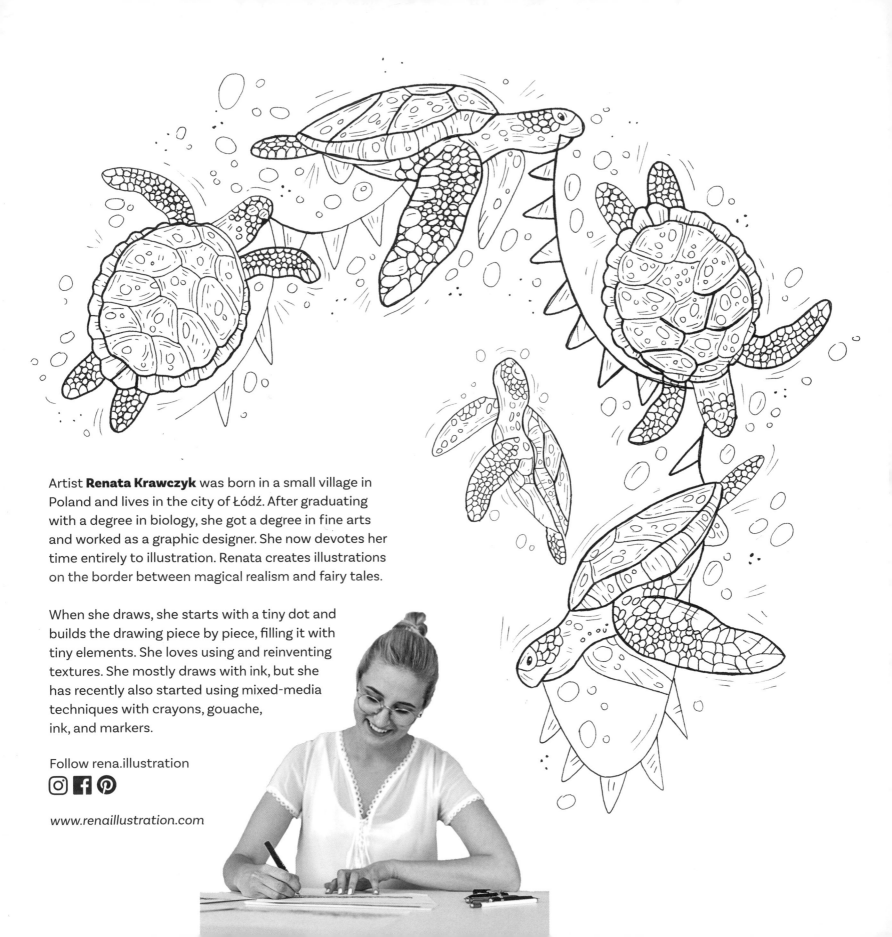

Artist **Renata Krawczyk** was born in a small village in Poland and lives in the city of Łódź. After graduating with a degree in biology, she got a degree in fine arts and worked as a graphic designer. She now devotes her time entirely to illustration. Renata creates illustrations on the border between magical realism and fairy tales.

When she draws, she starts with a tiny dot and builds the drawing piece by piece, filling it with tiny elements. She loves using and reinventing textures. She mostly draws with ink, but she has recently also started using mixed-media techniques with crayons, gouache, ink, and markers.

Follow rena.illustration

www.renaillustration.com

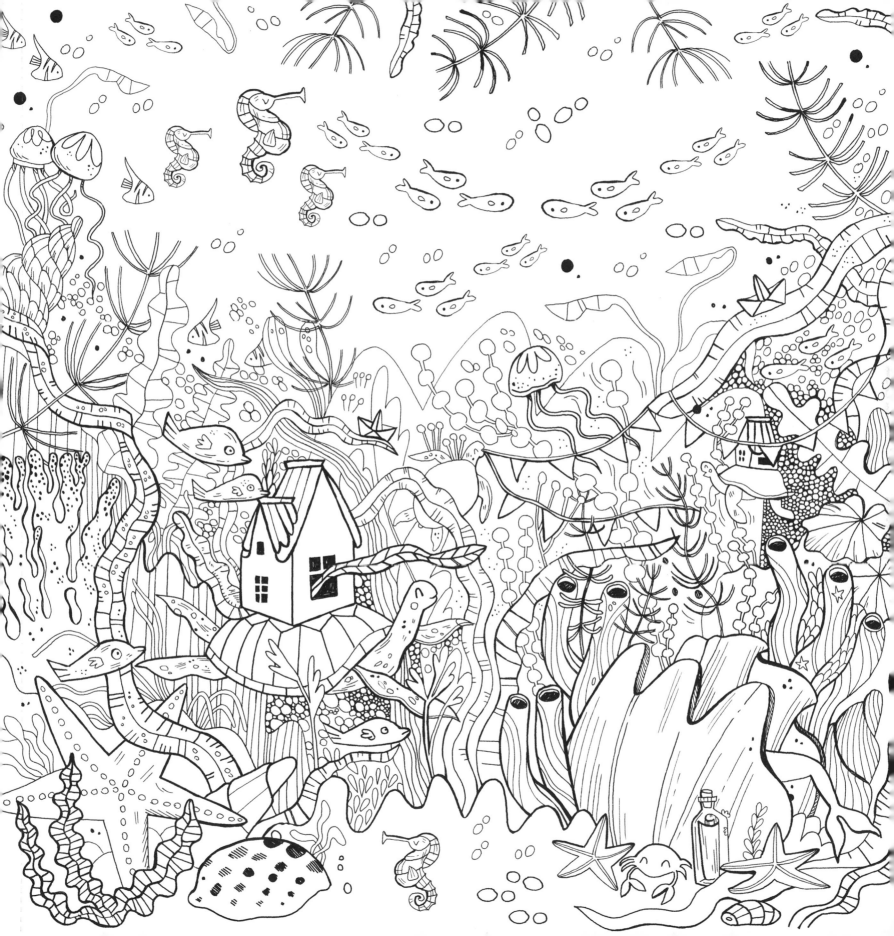

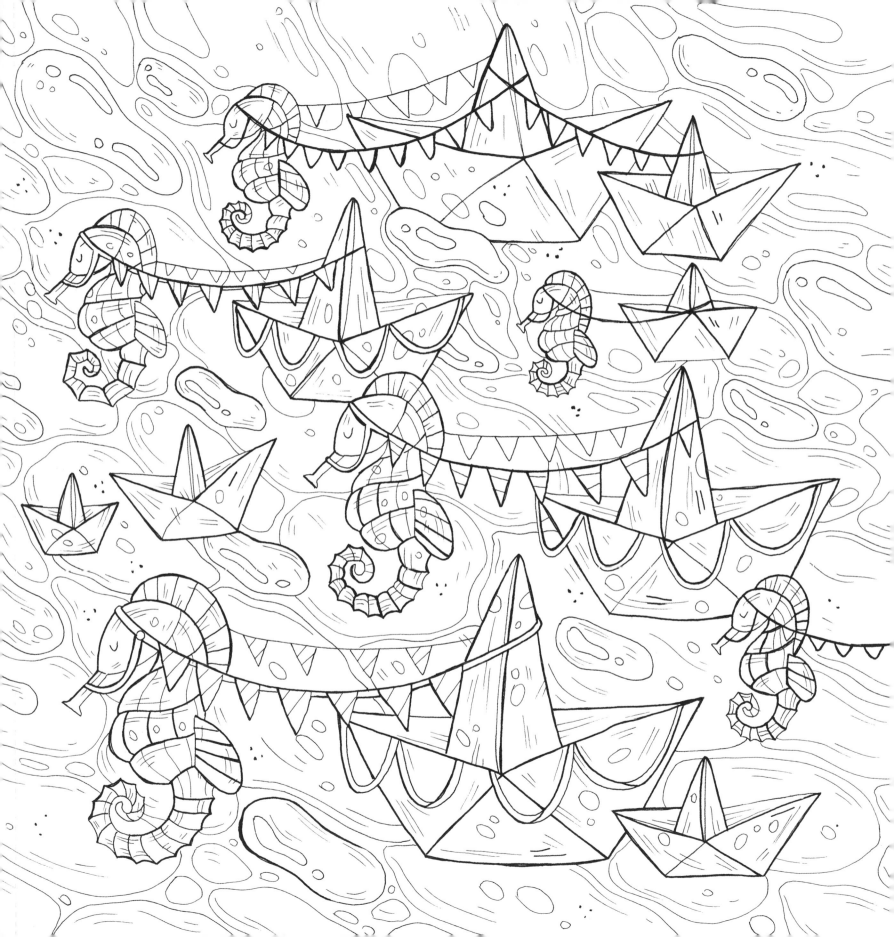

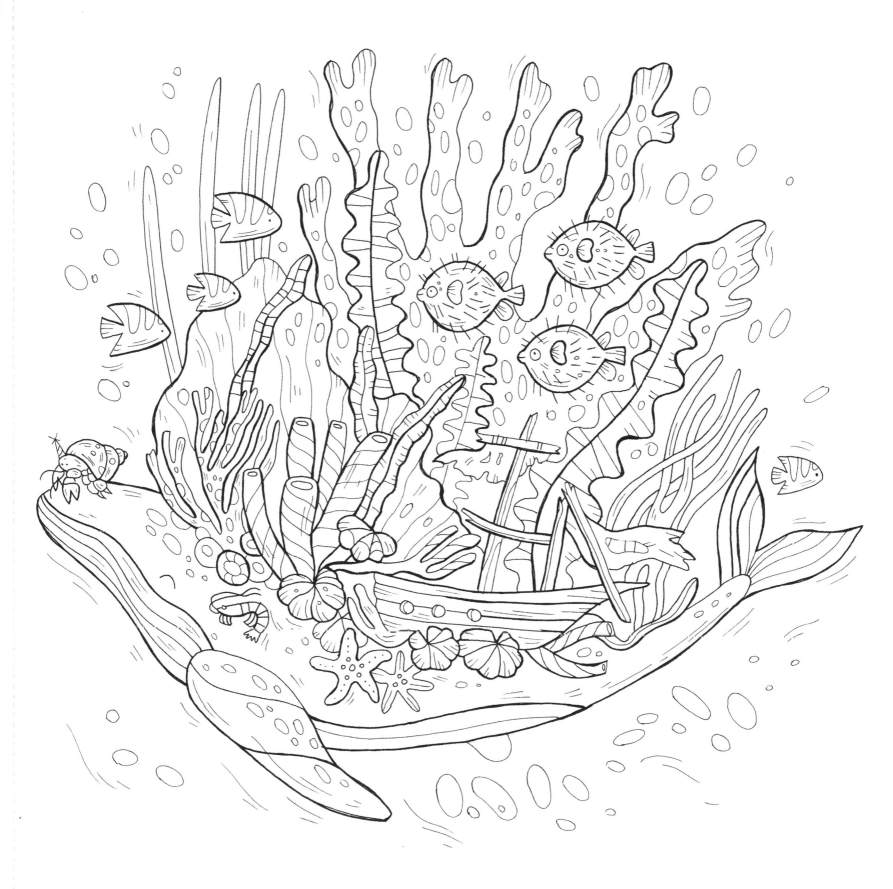

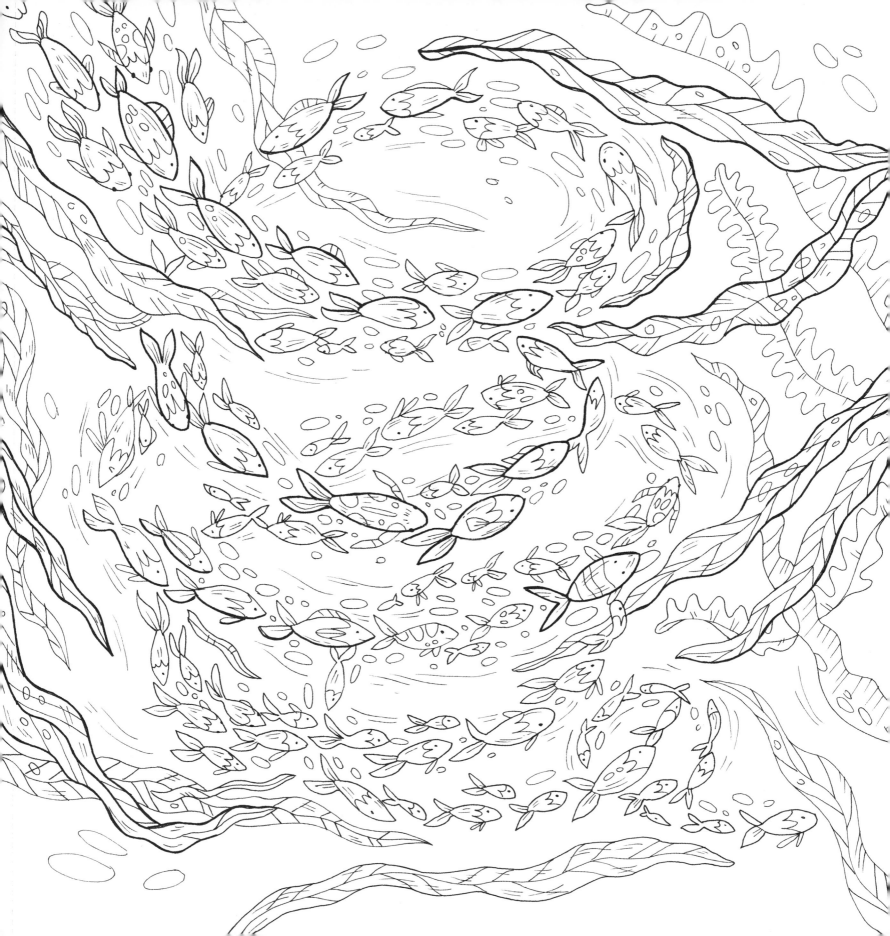

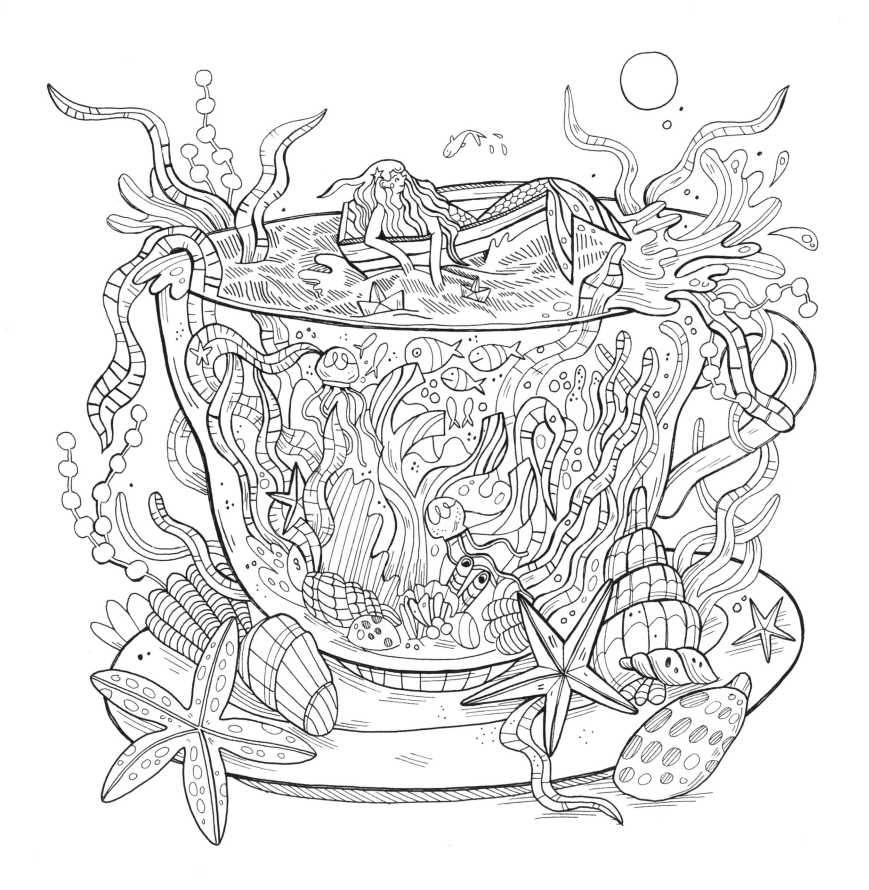

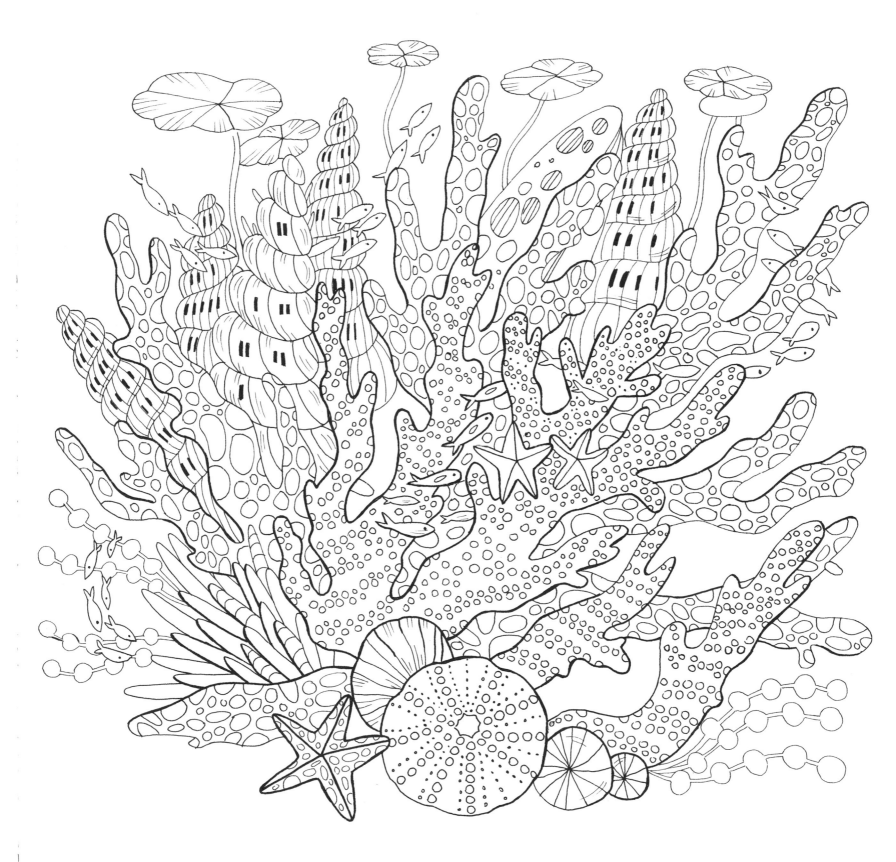

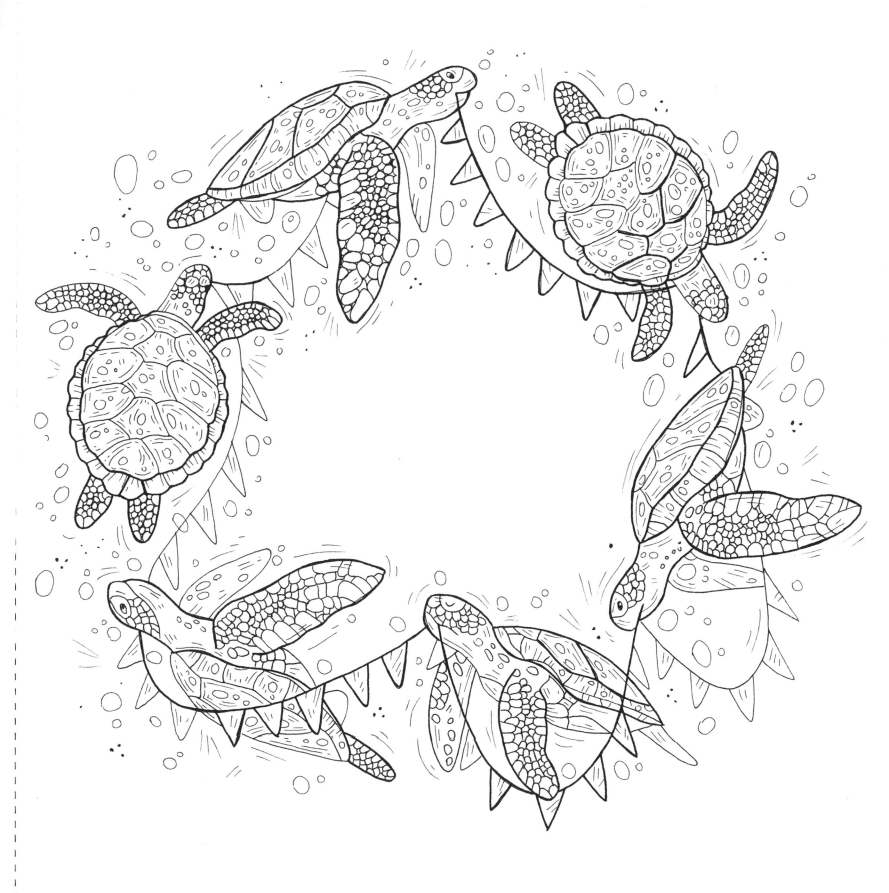

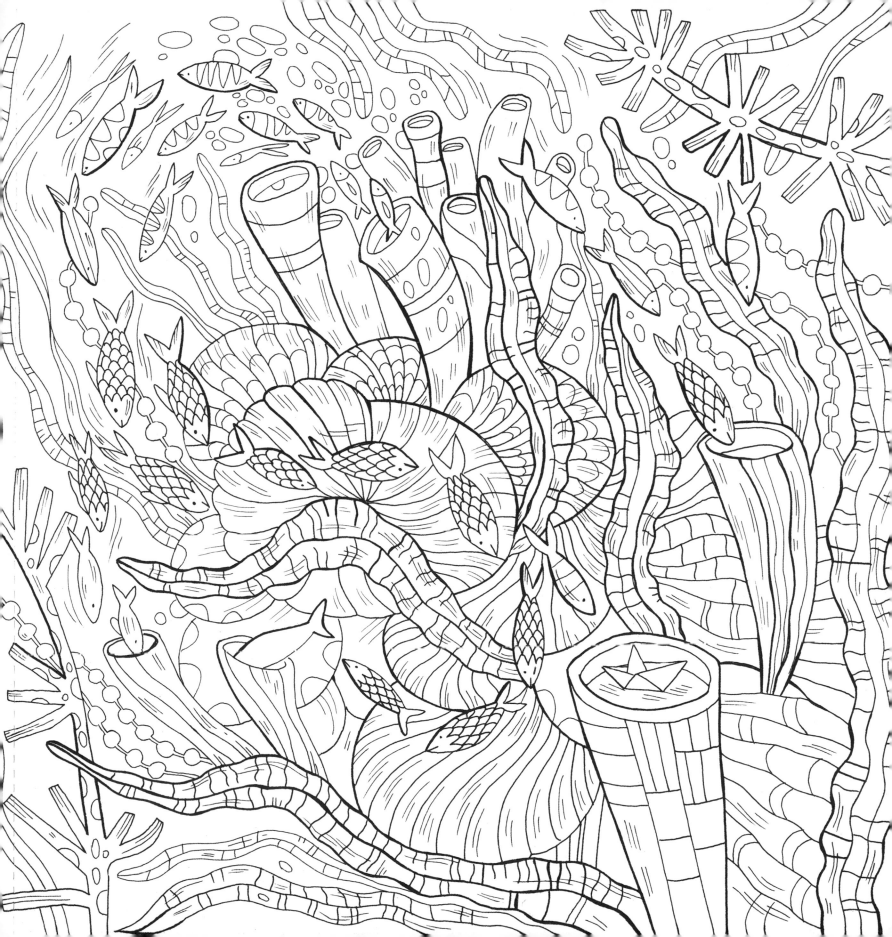

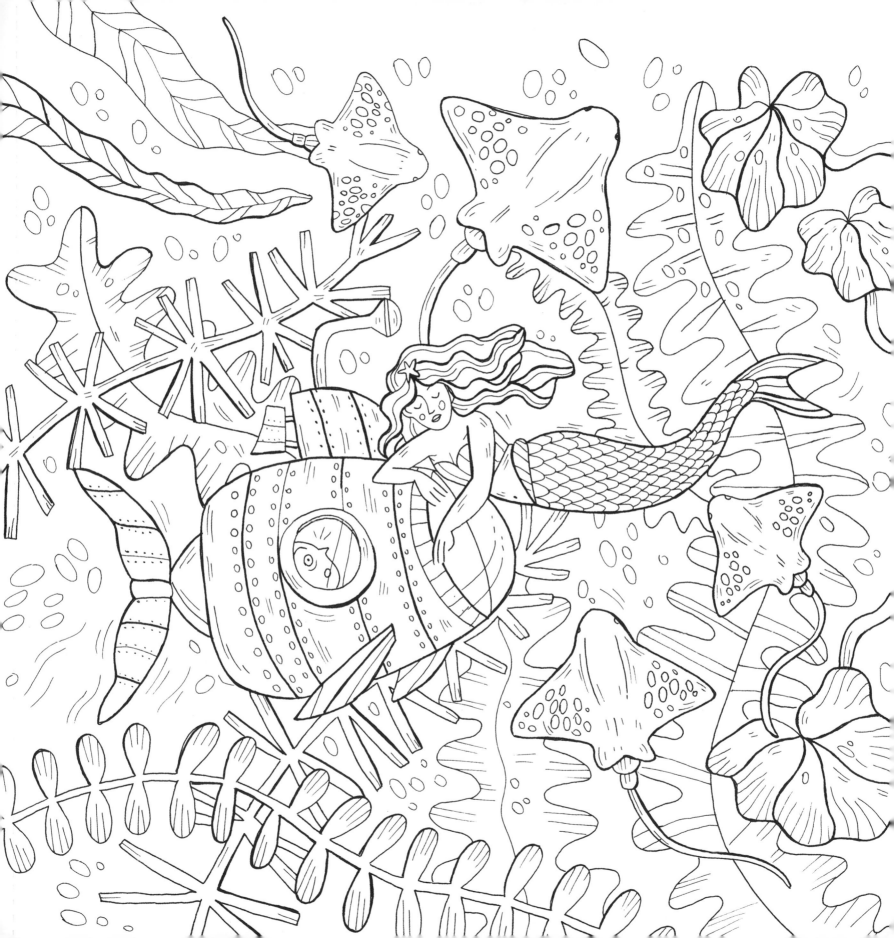

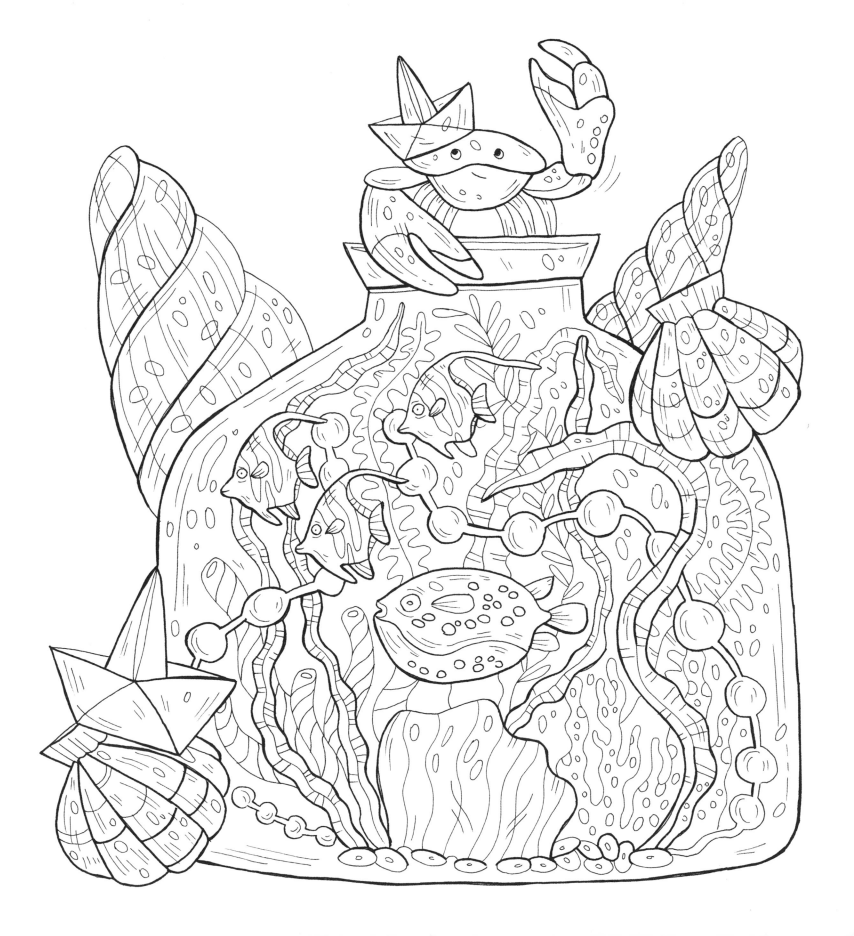

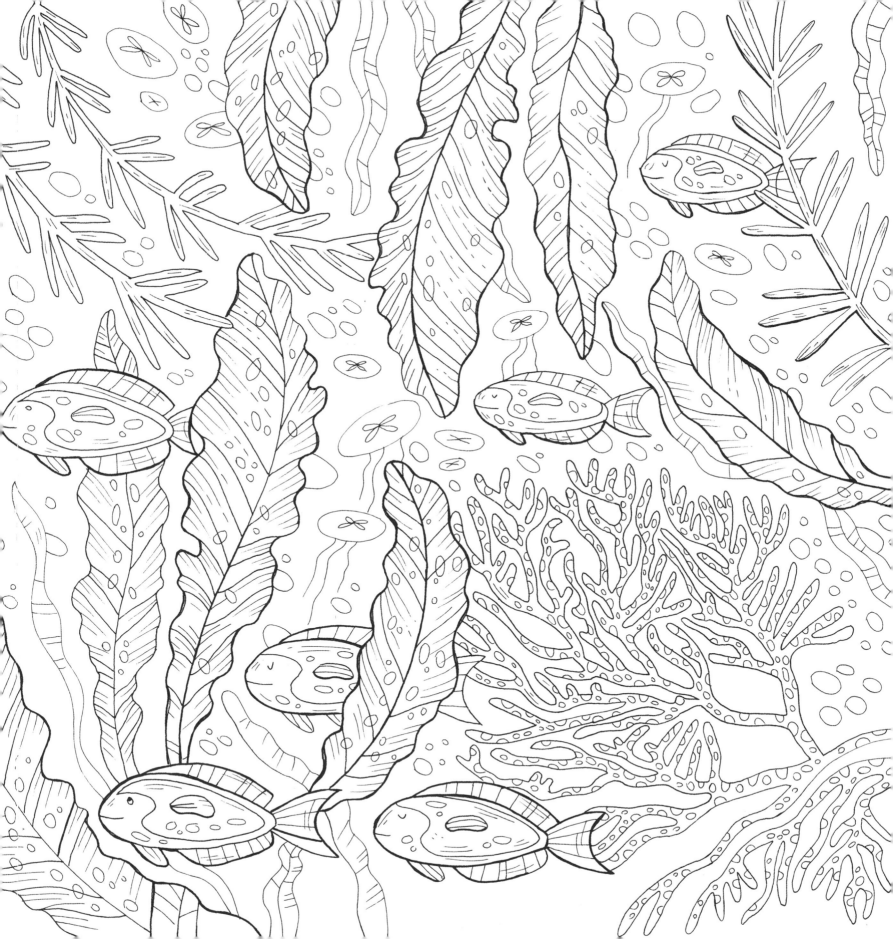

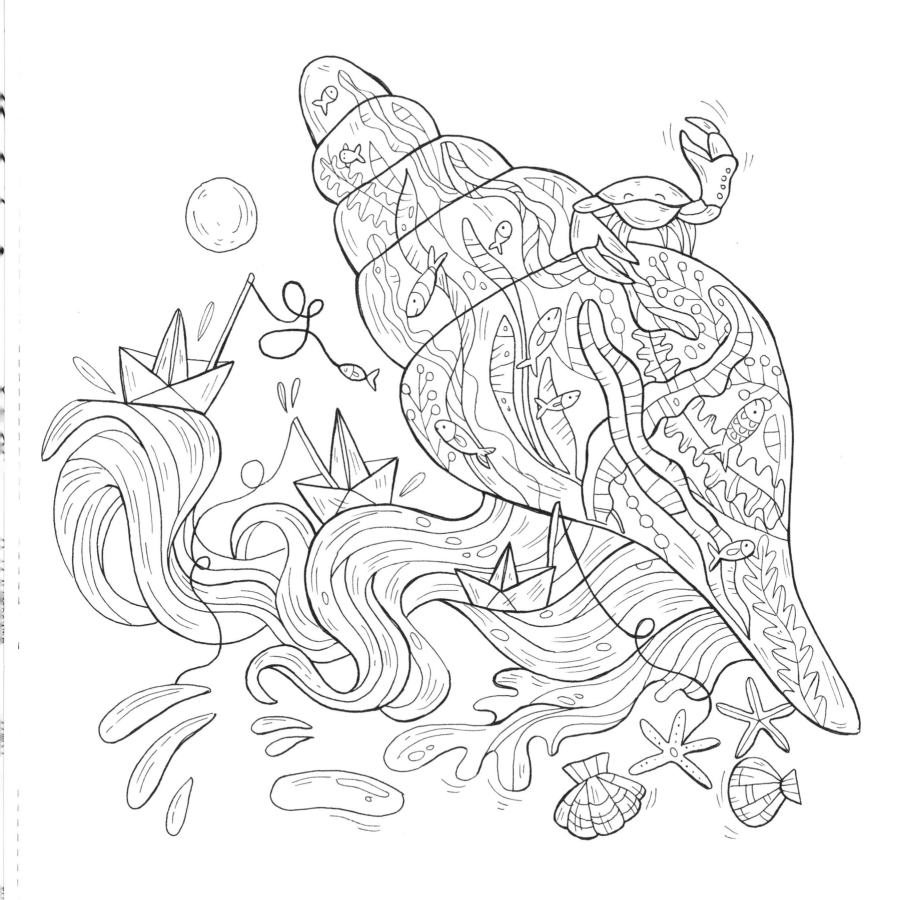

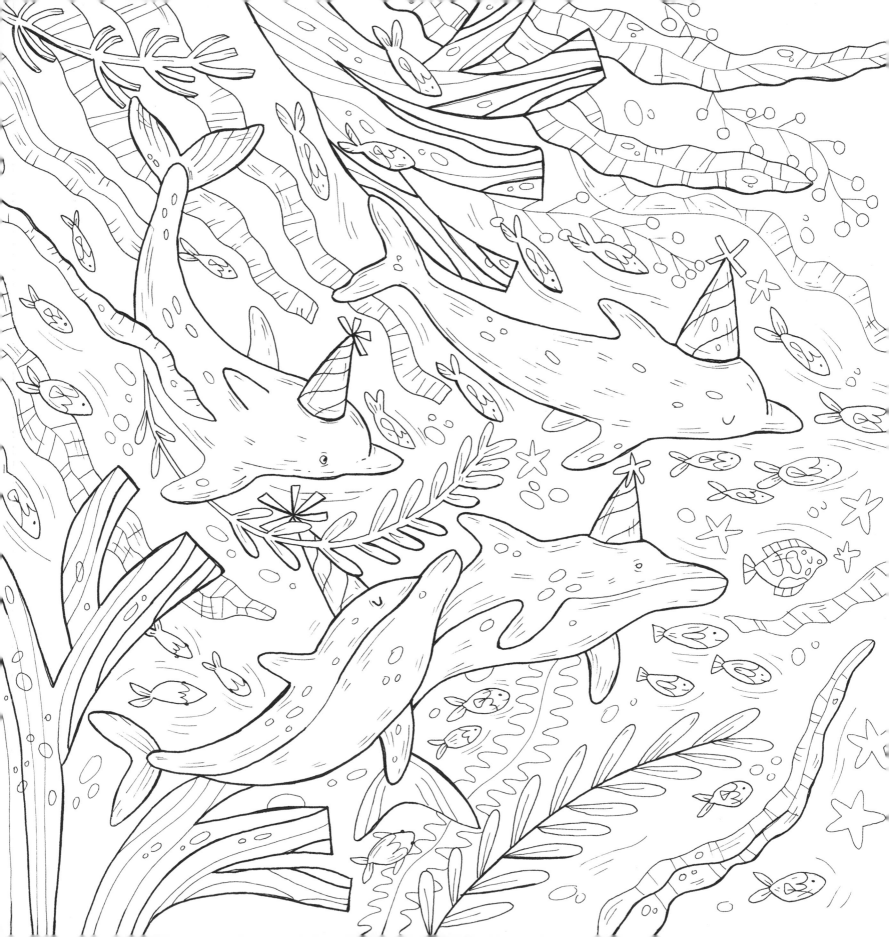

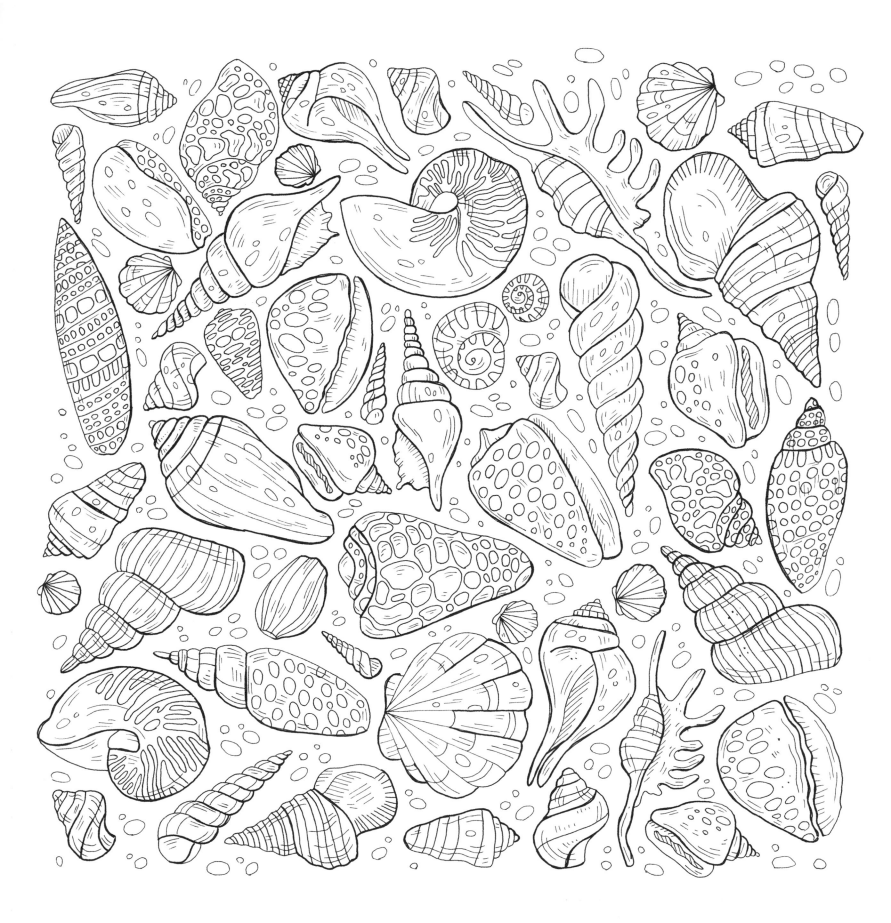

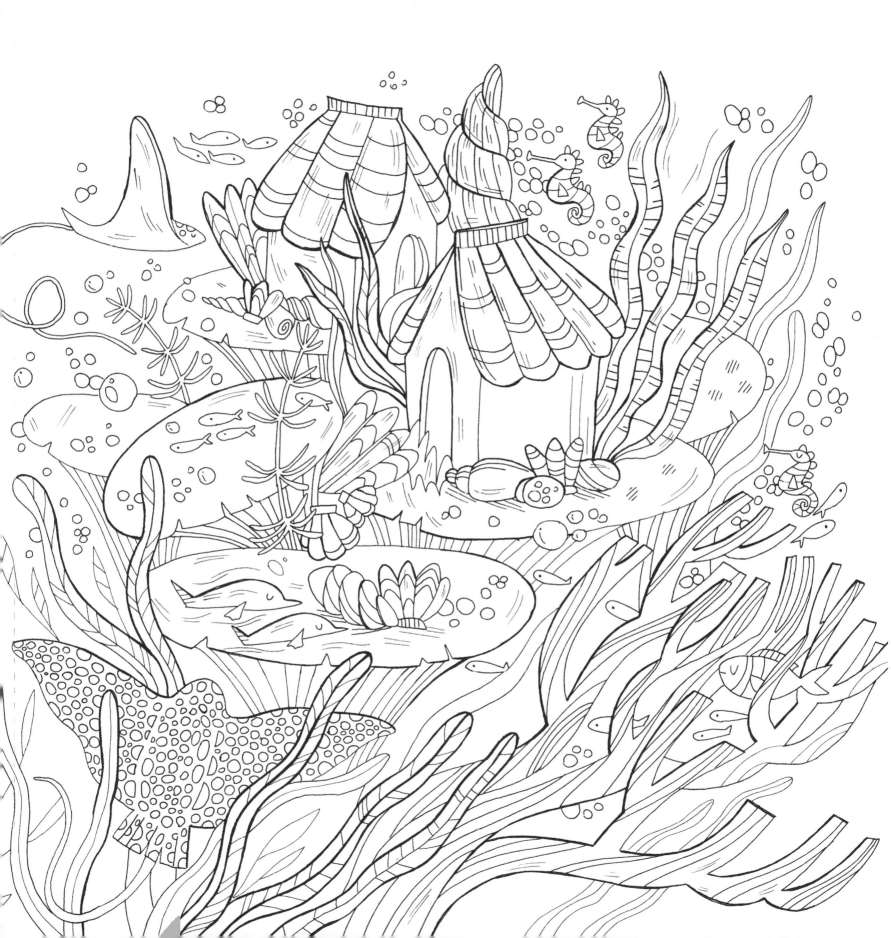

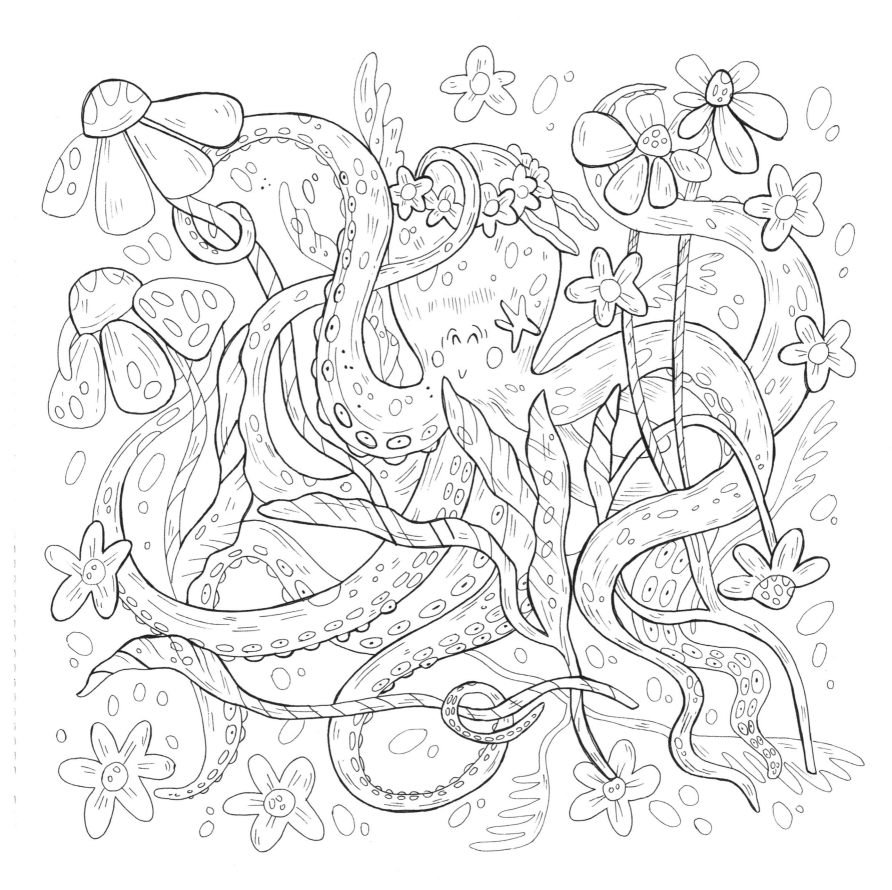

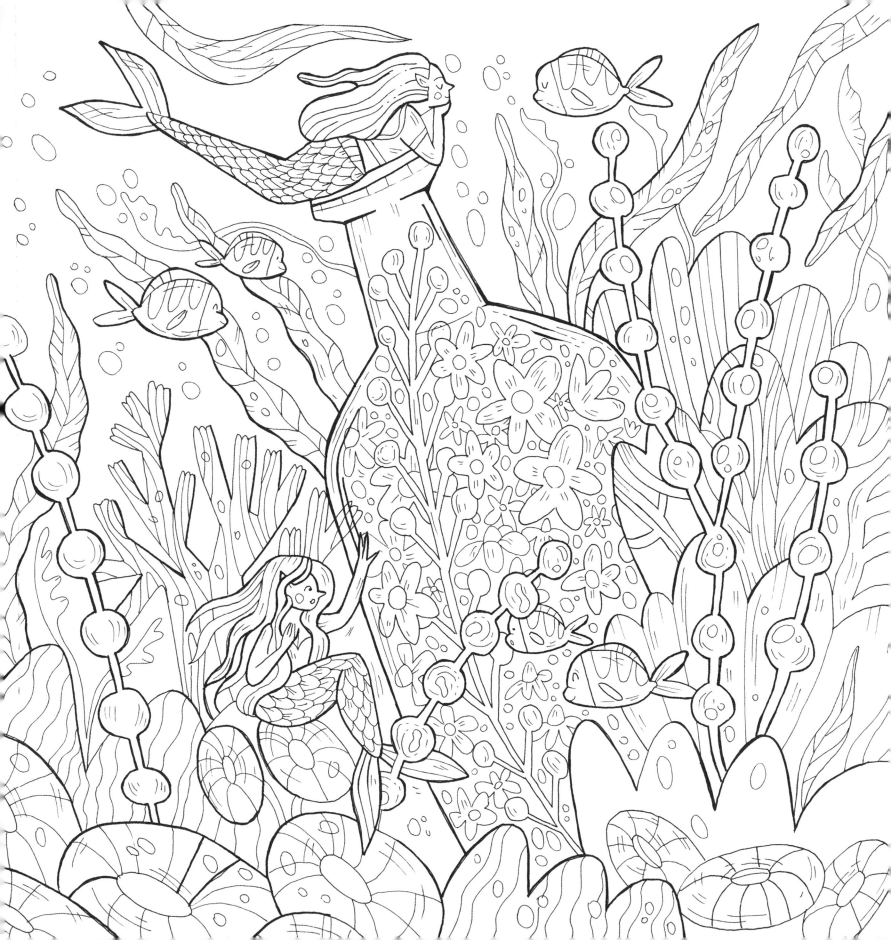

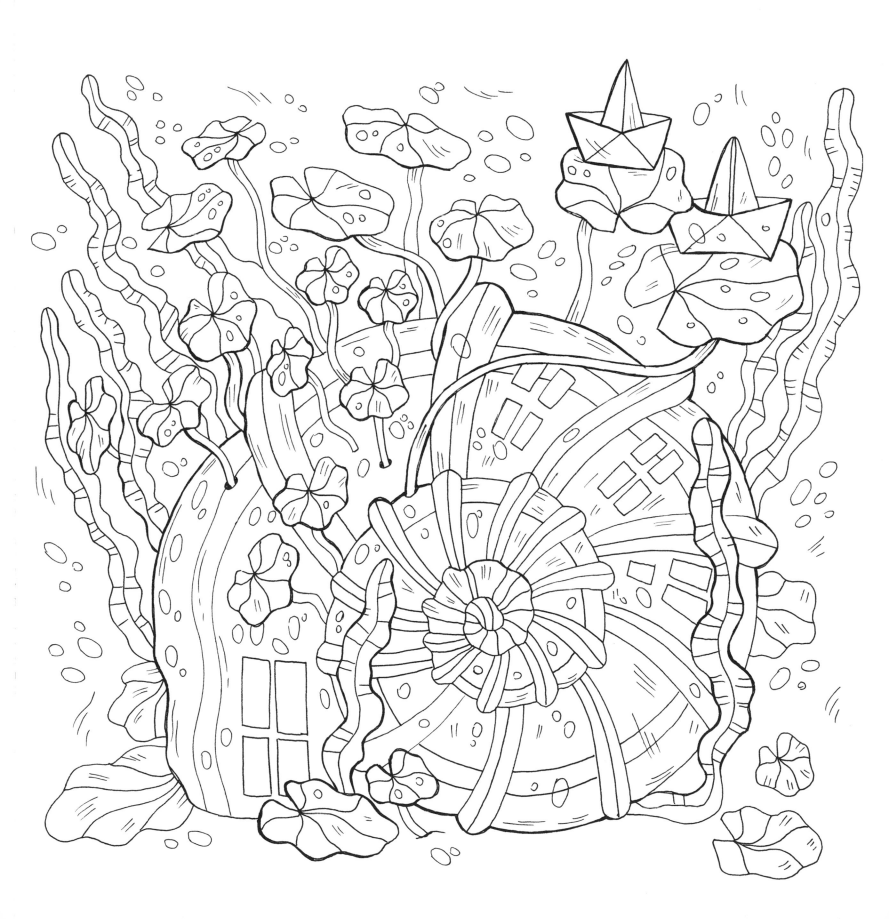

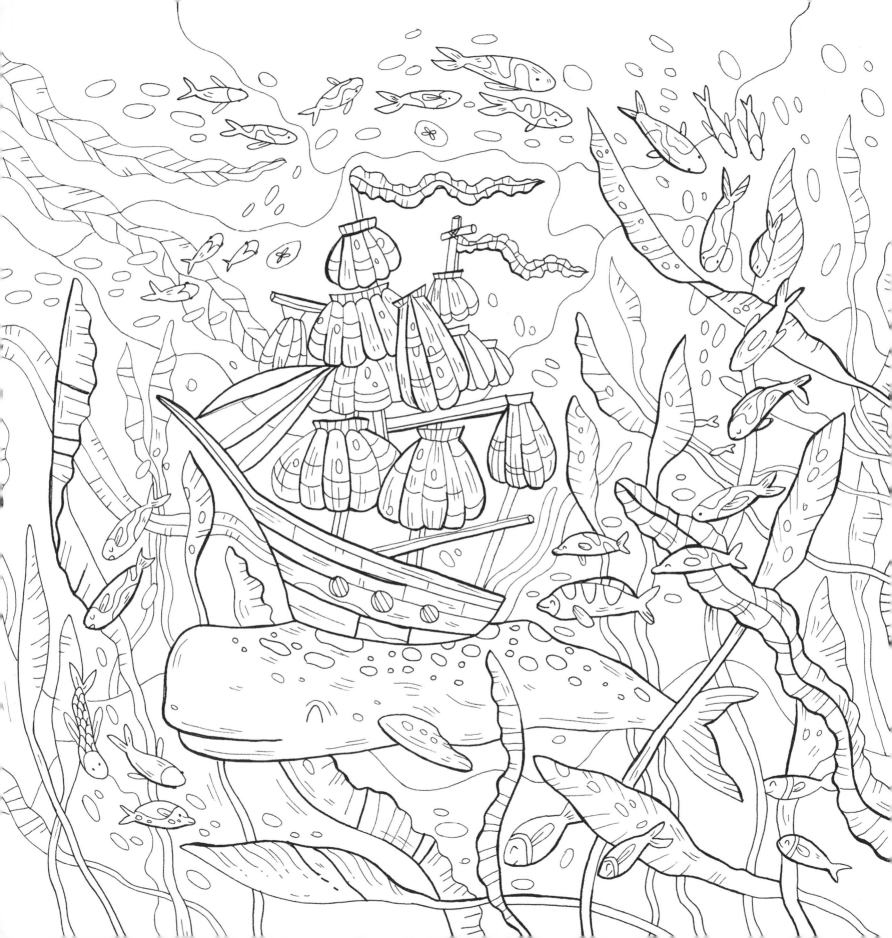

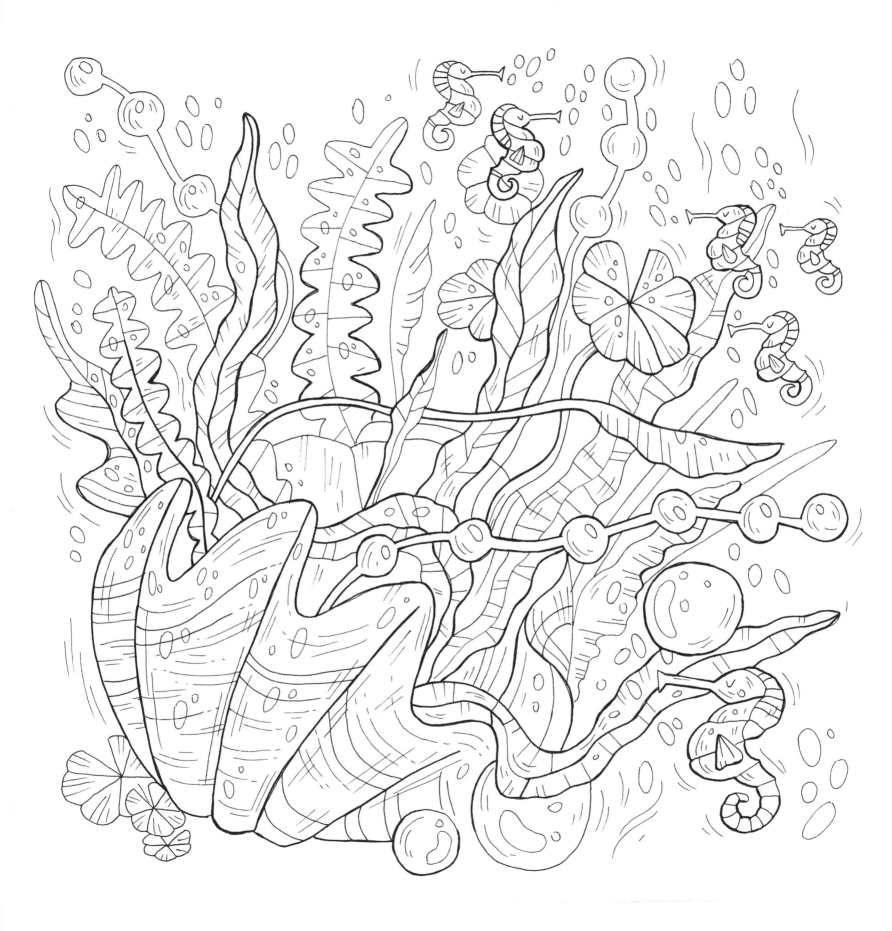

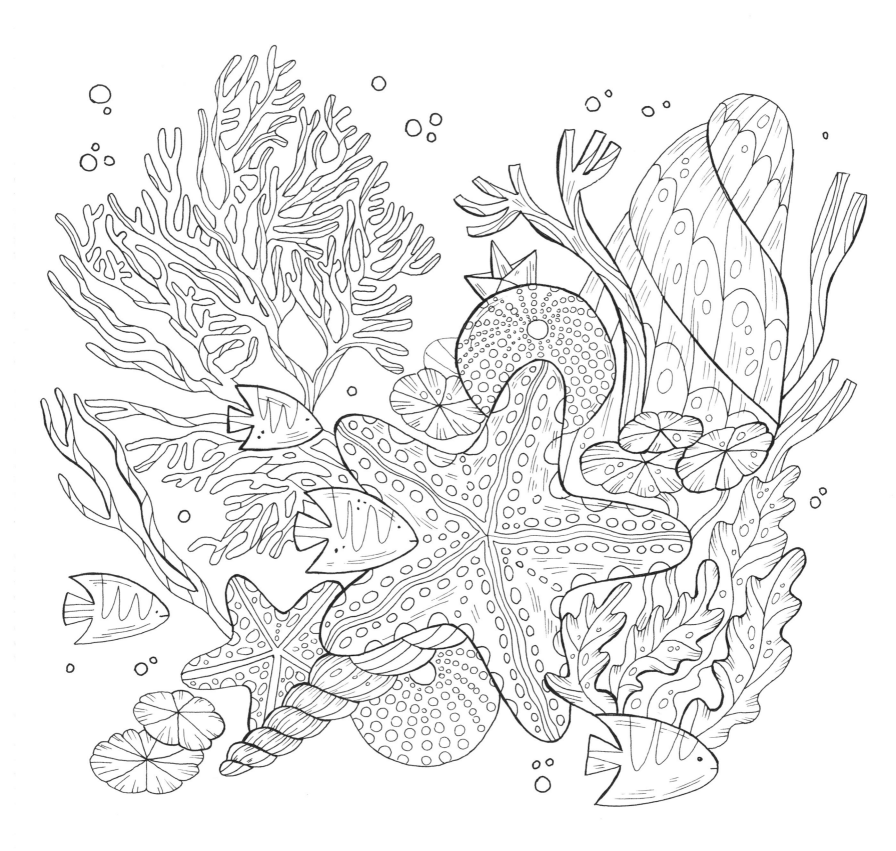

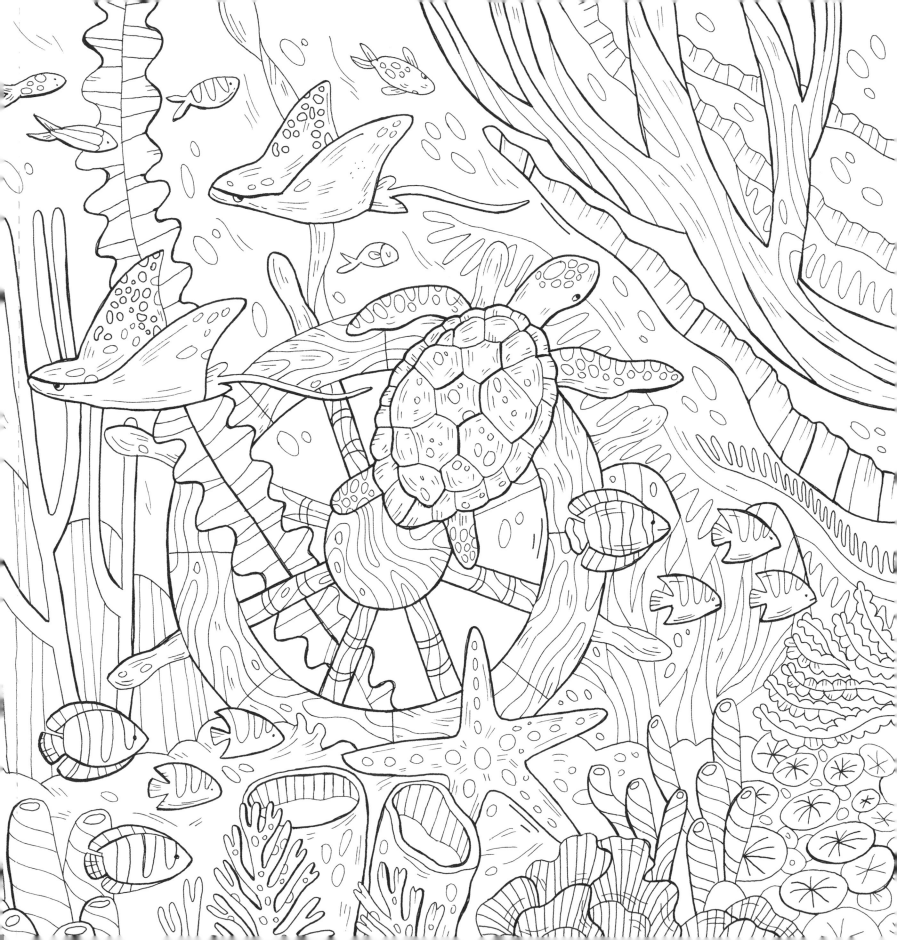

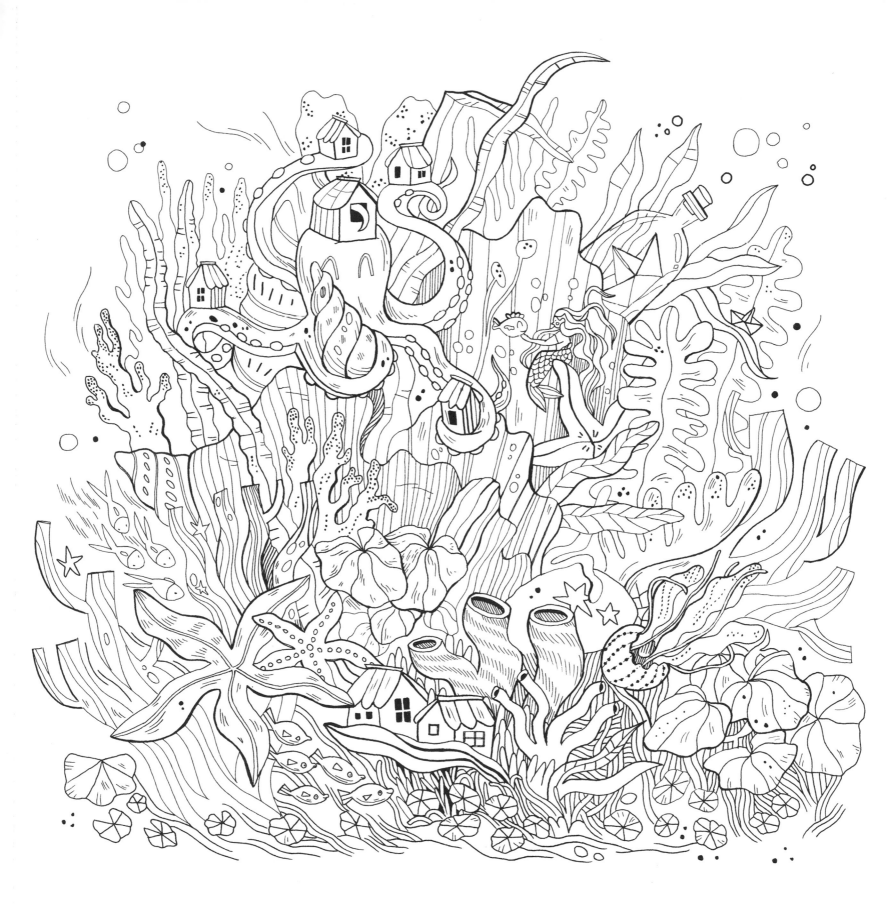

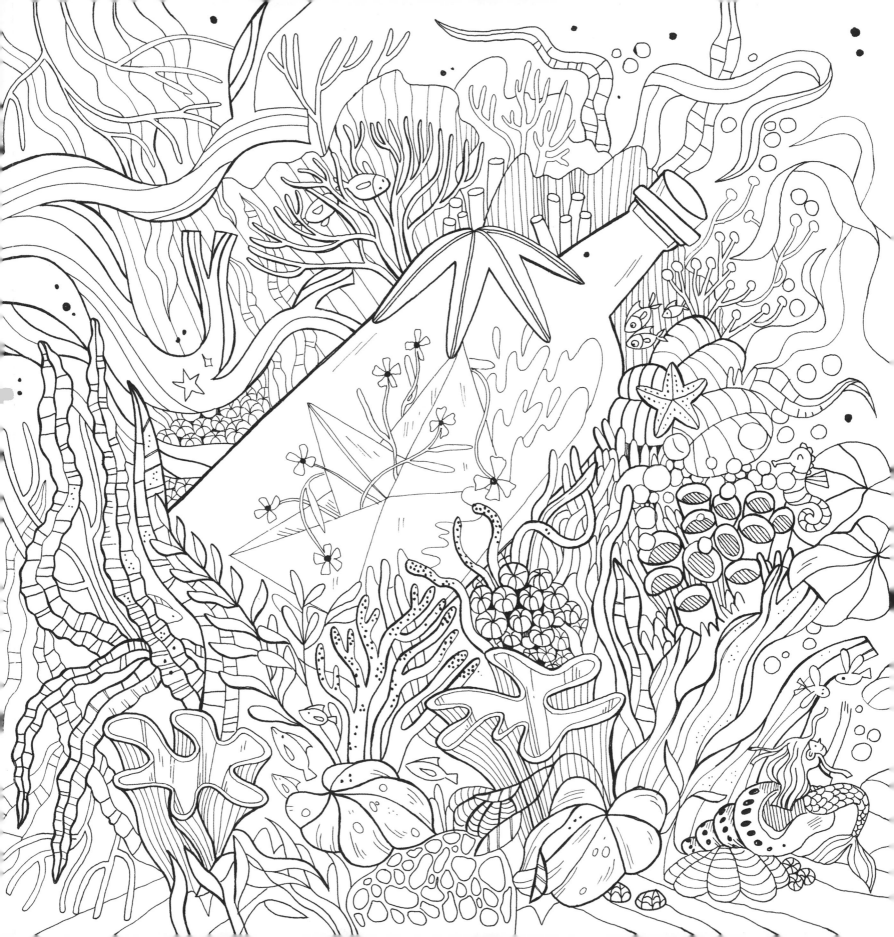

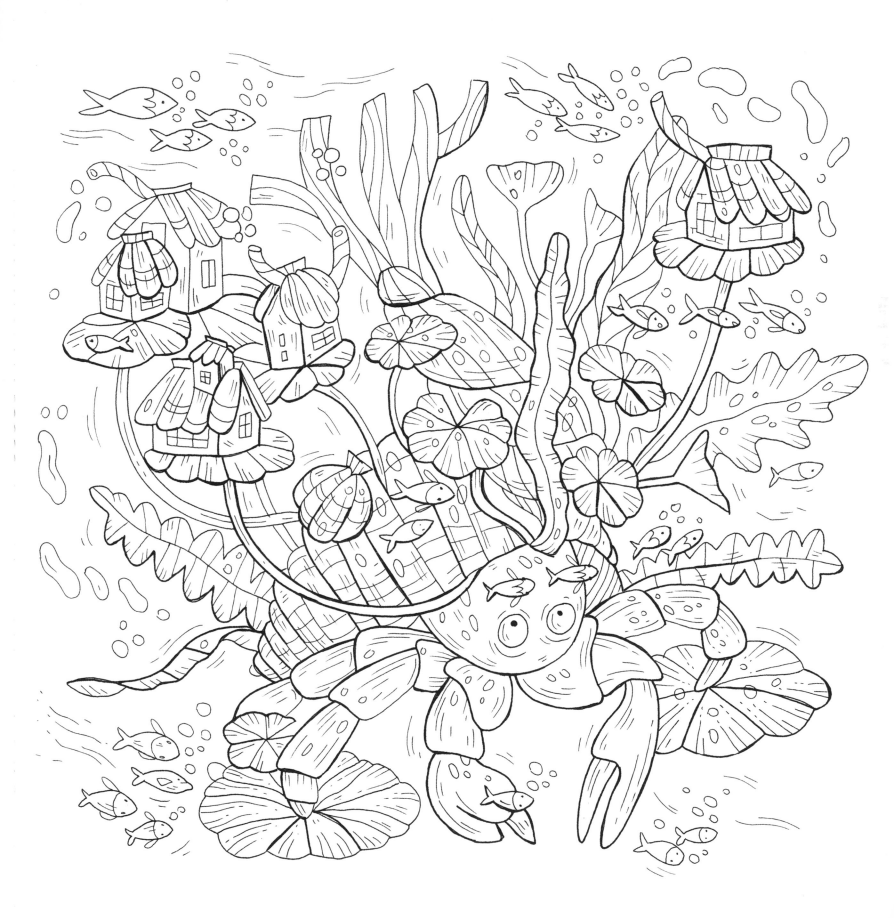

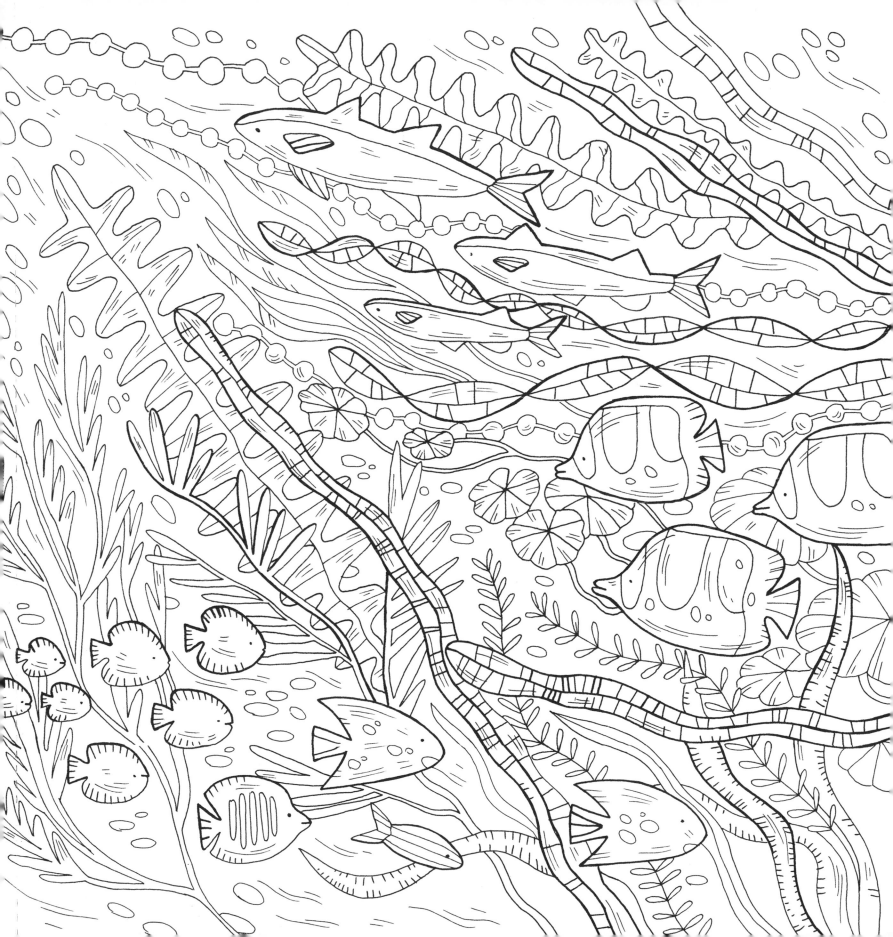

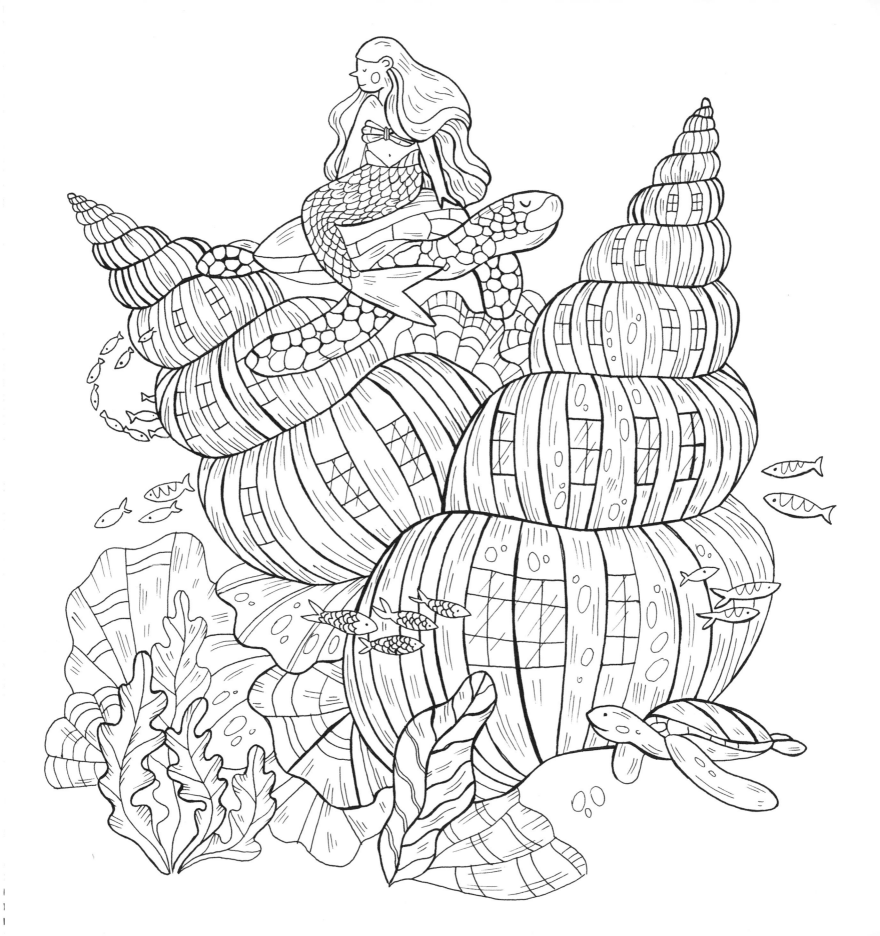

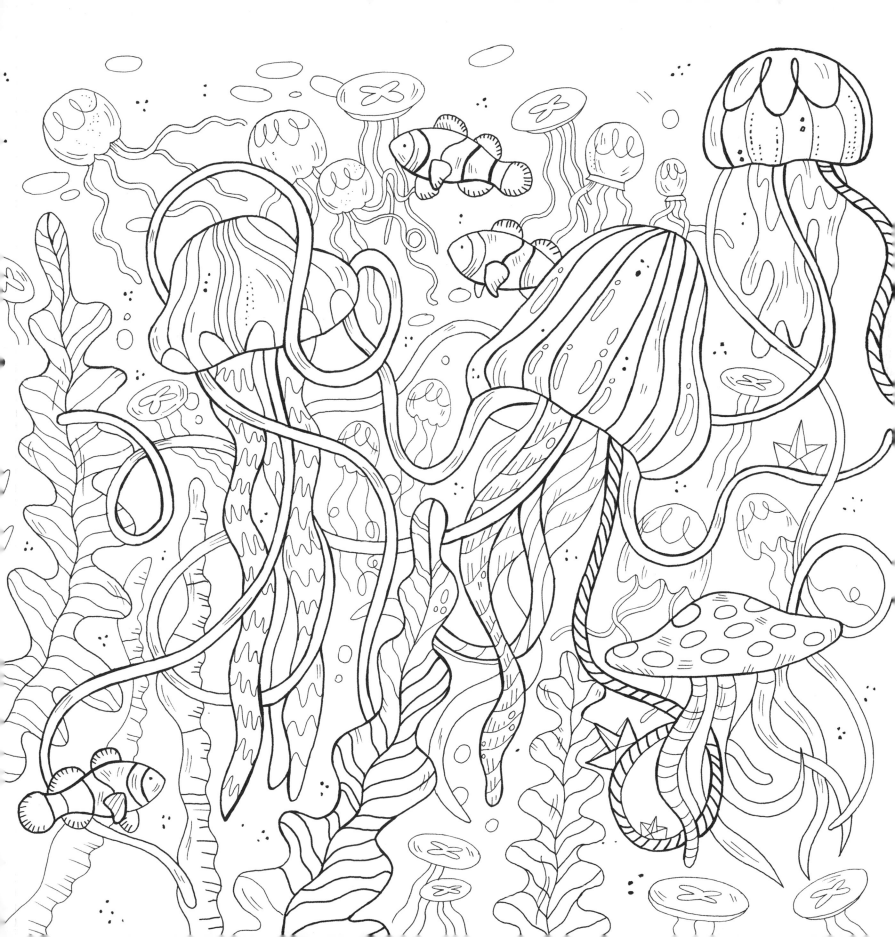

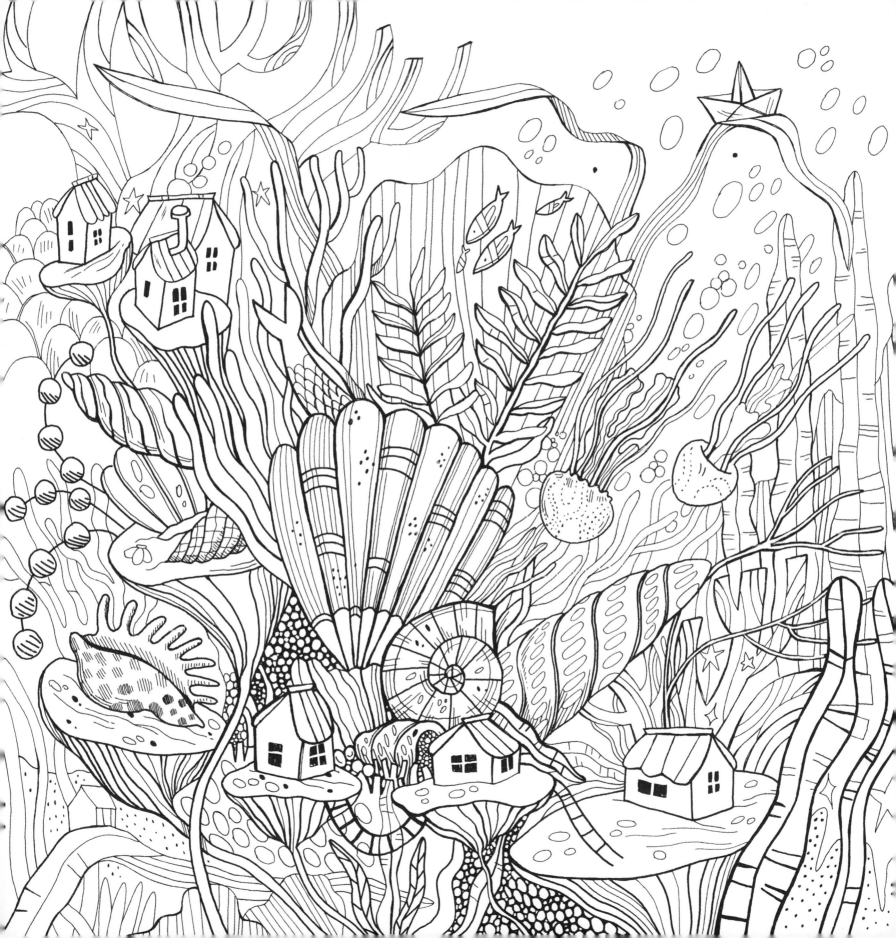

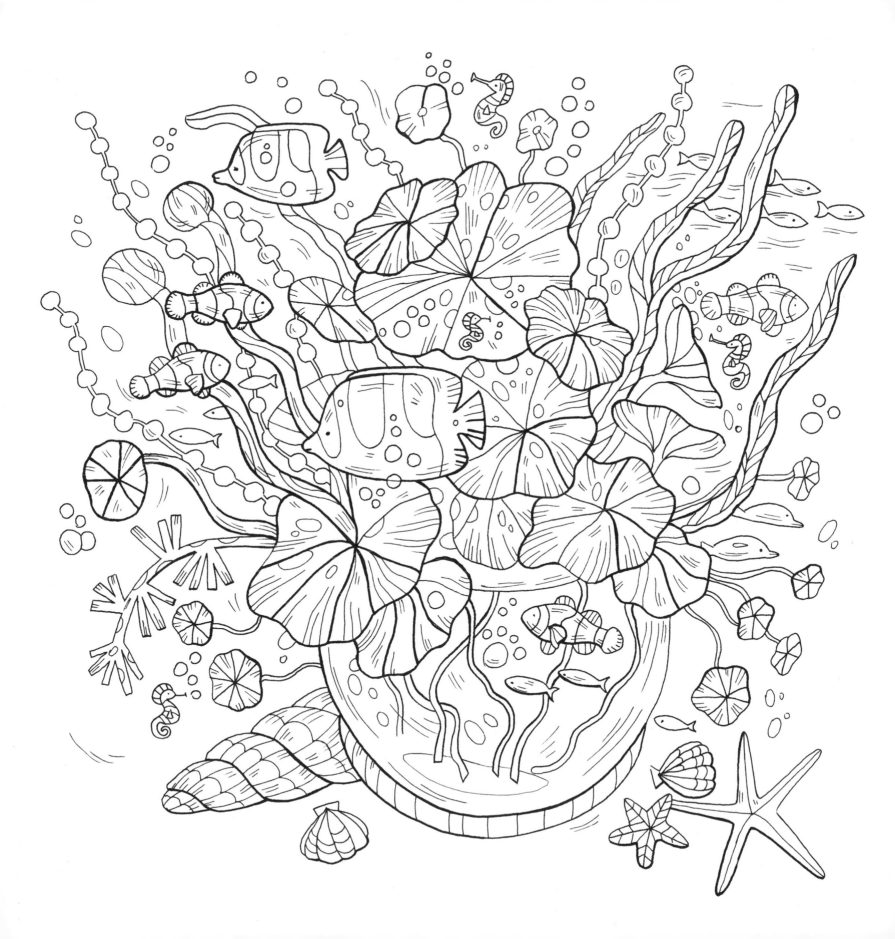

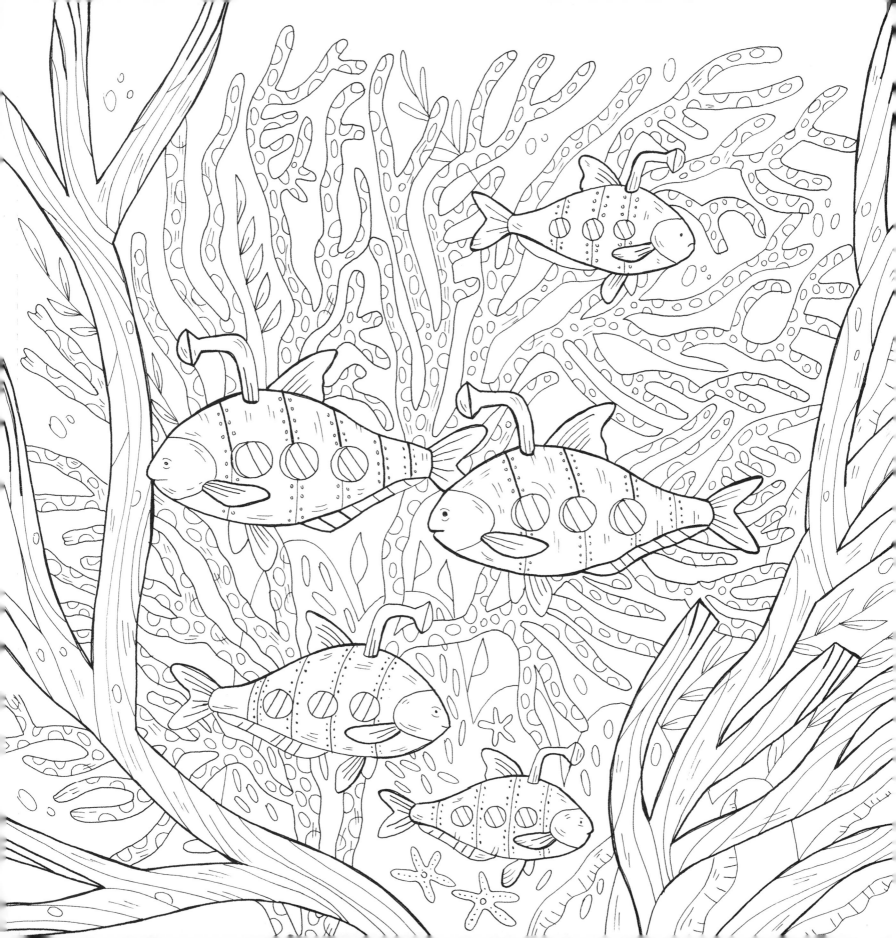

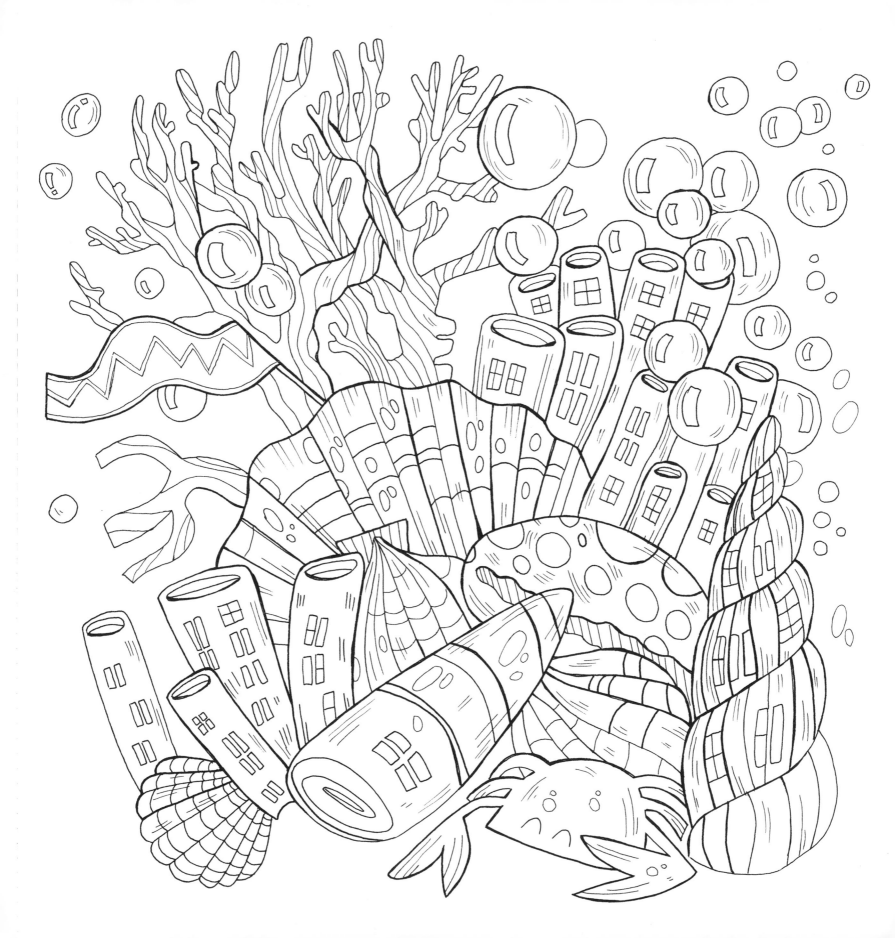

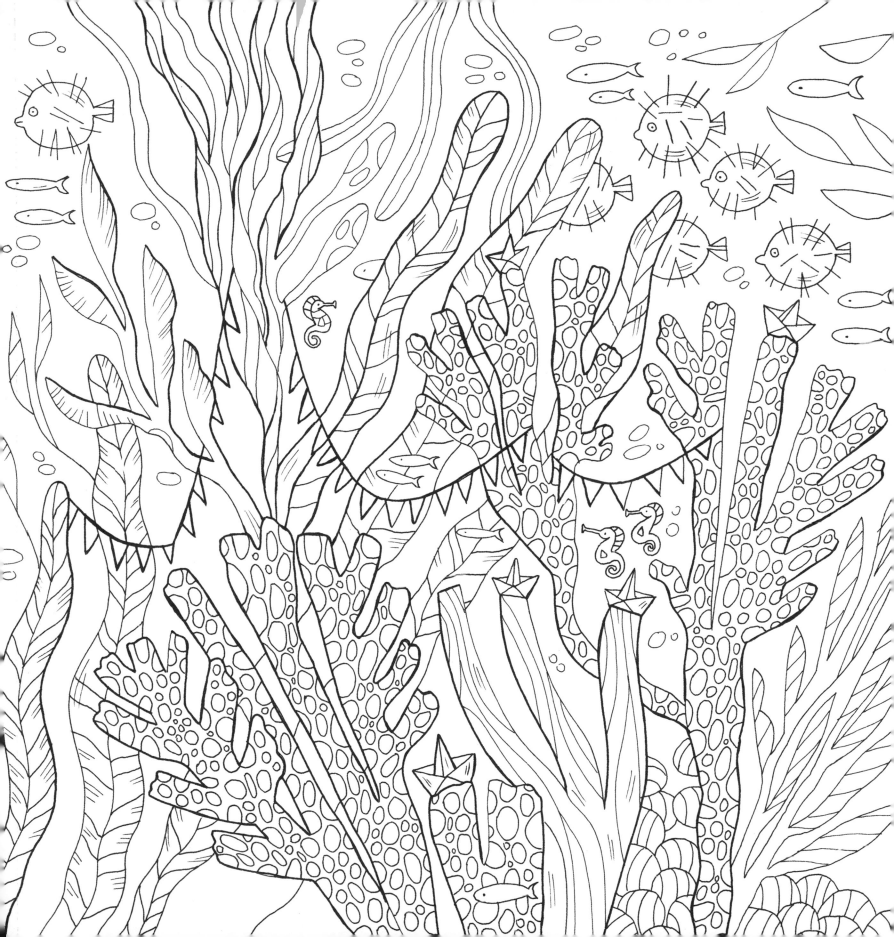

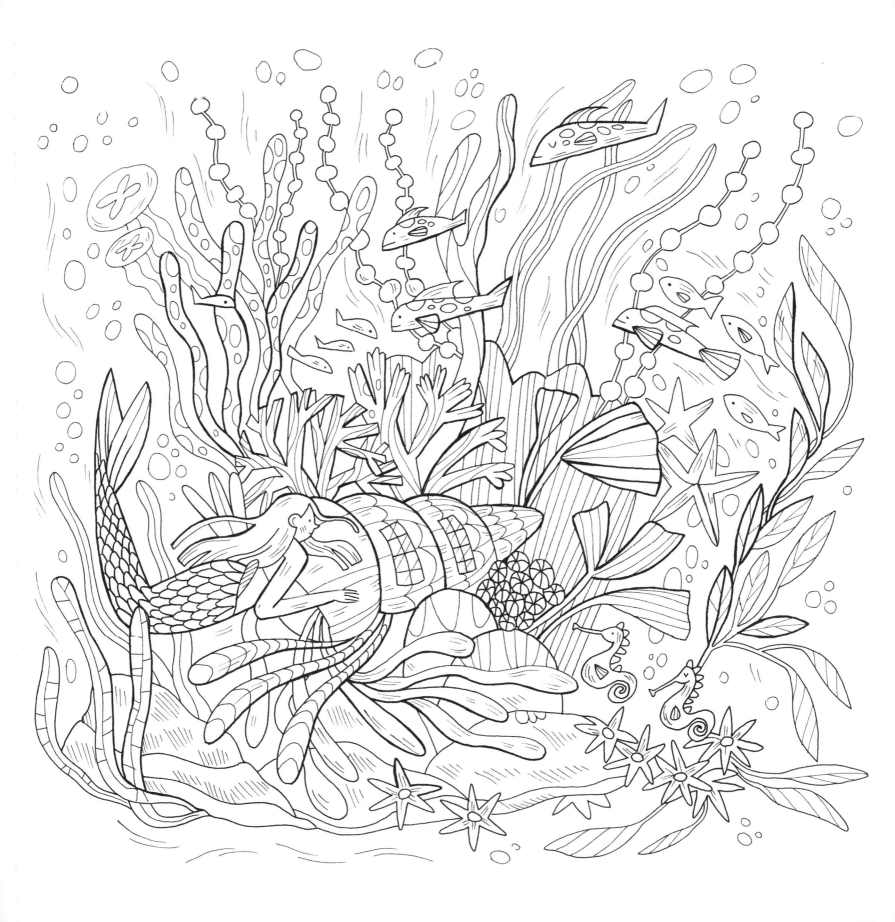

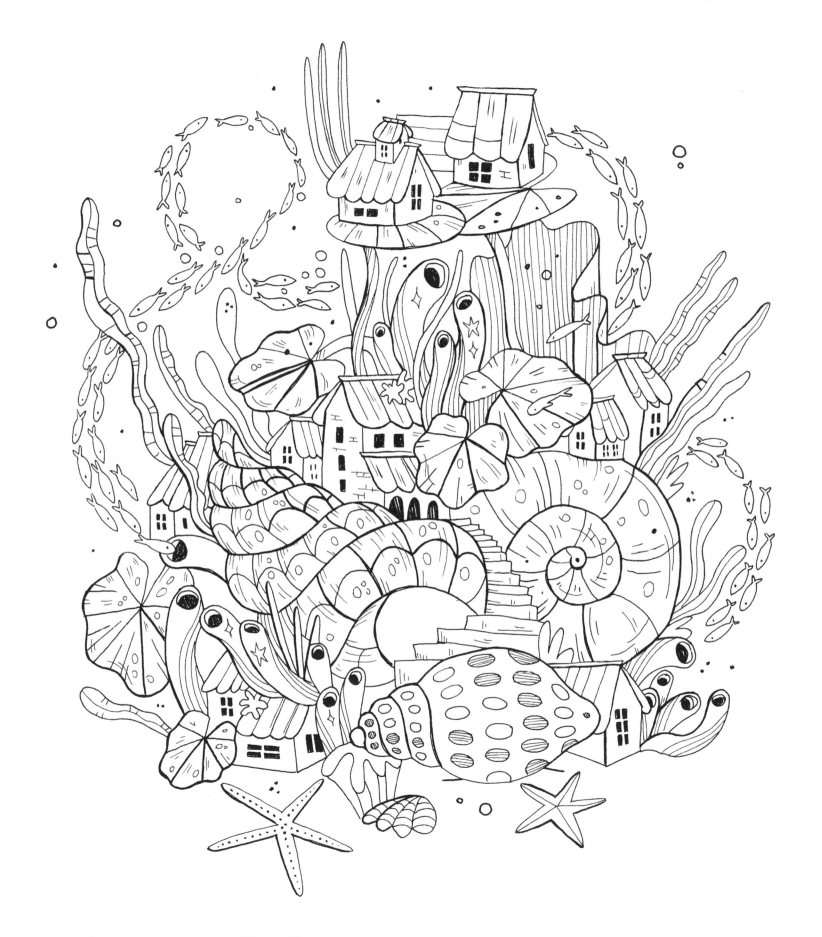

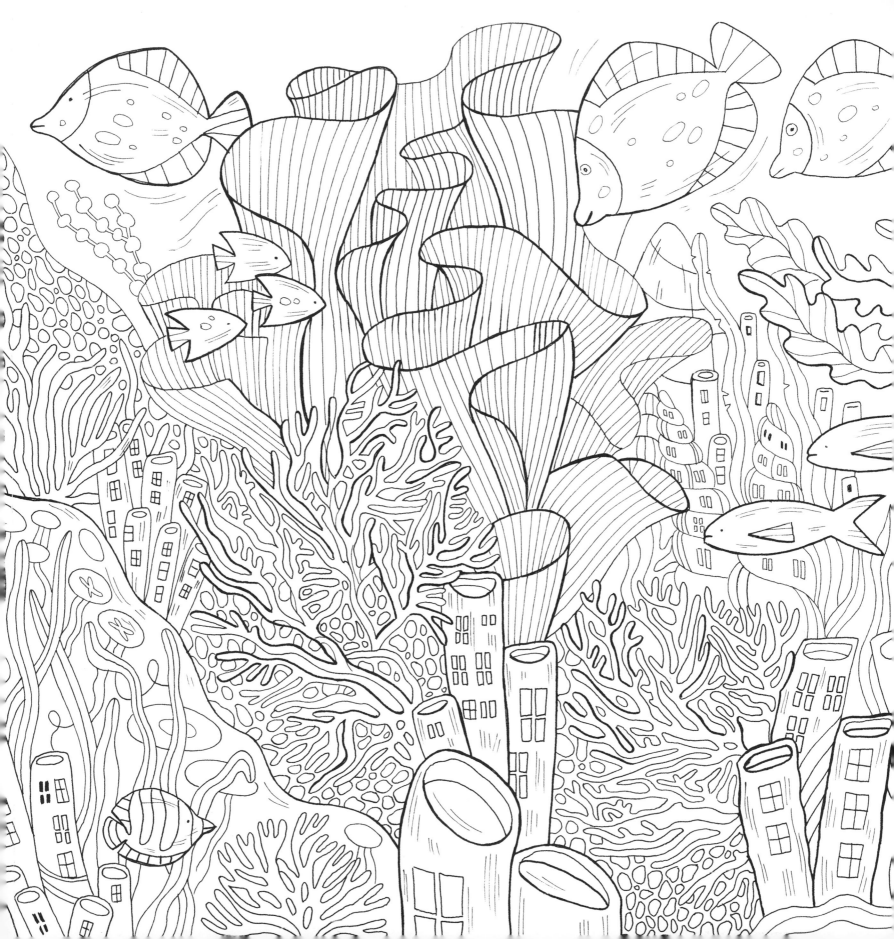

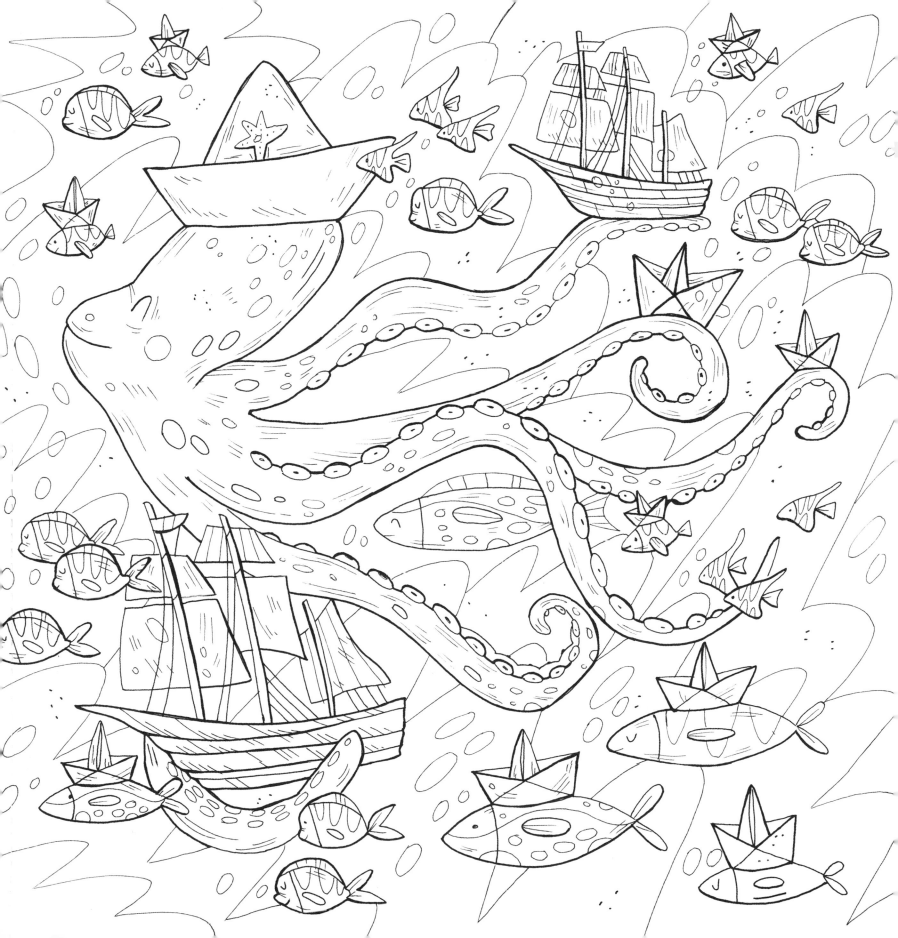

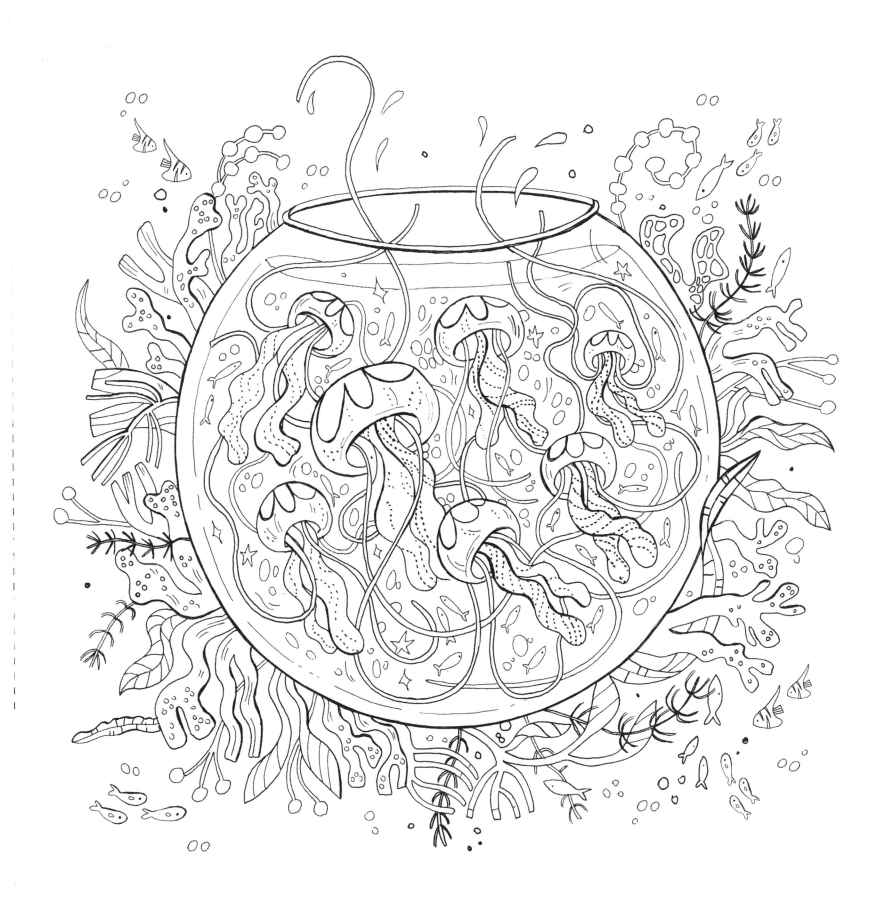

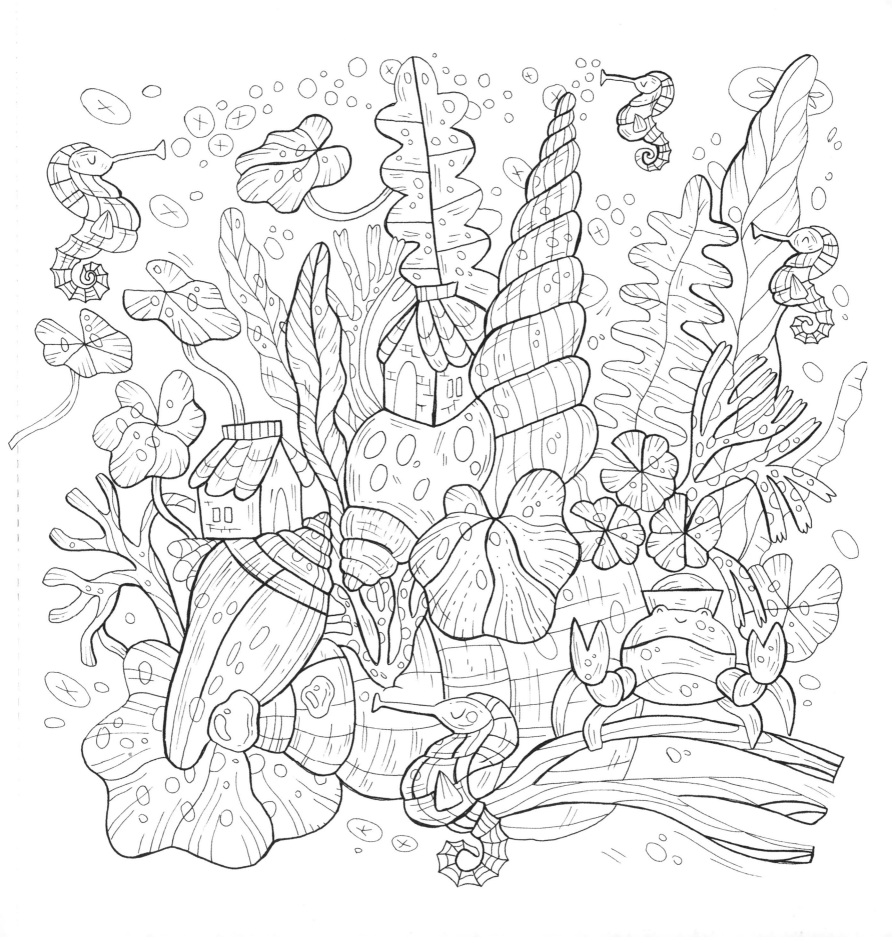

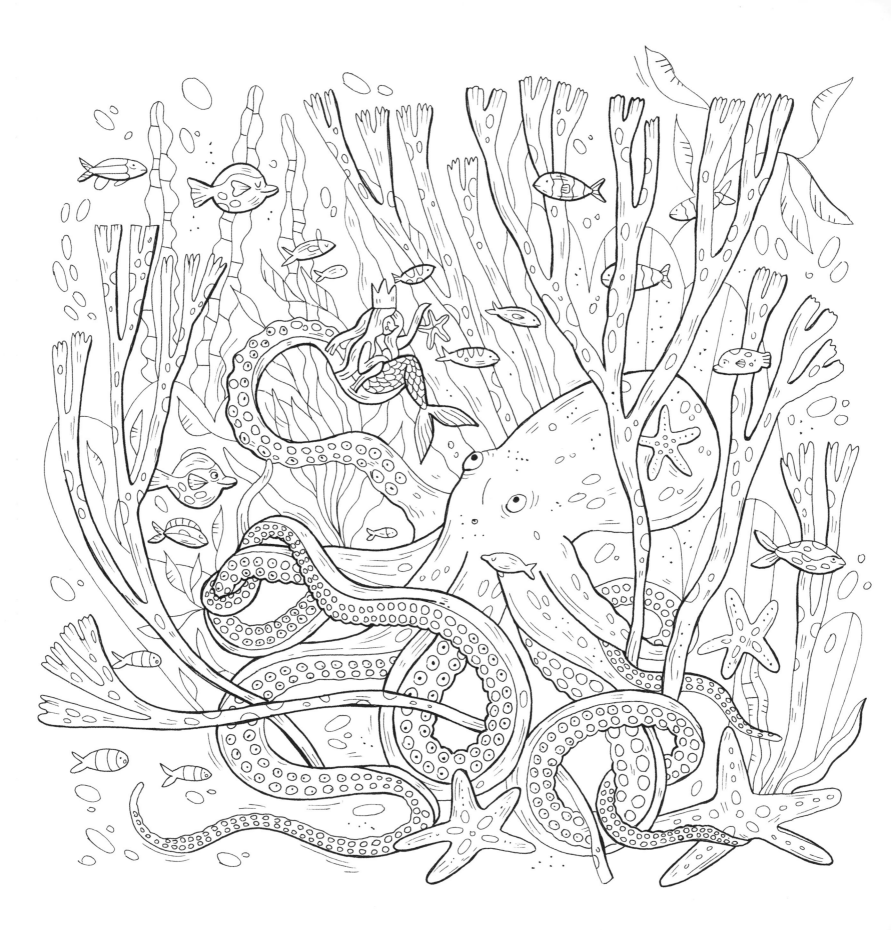

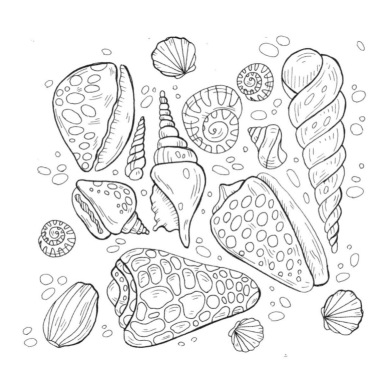